Sports Illustrated

In the
PAINT

*The complete body-painting
collection from the
SI Swimsuit Issue*

THE ART OF JOANNE GAIR

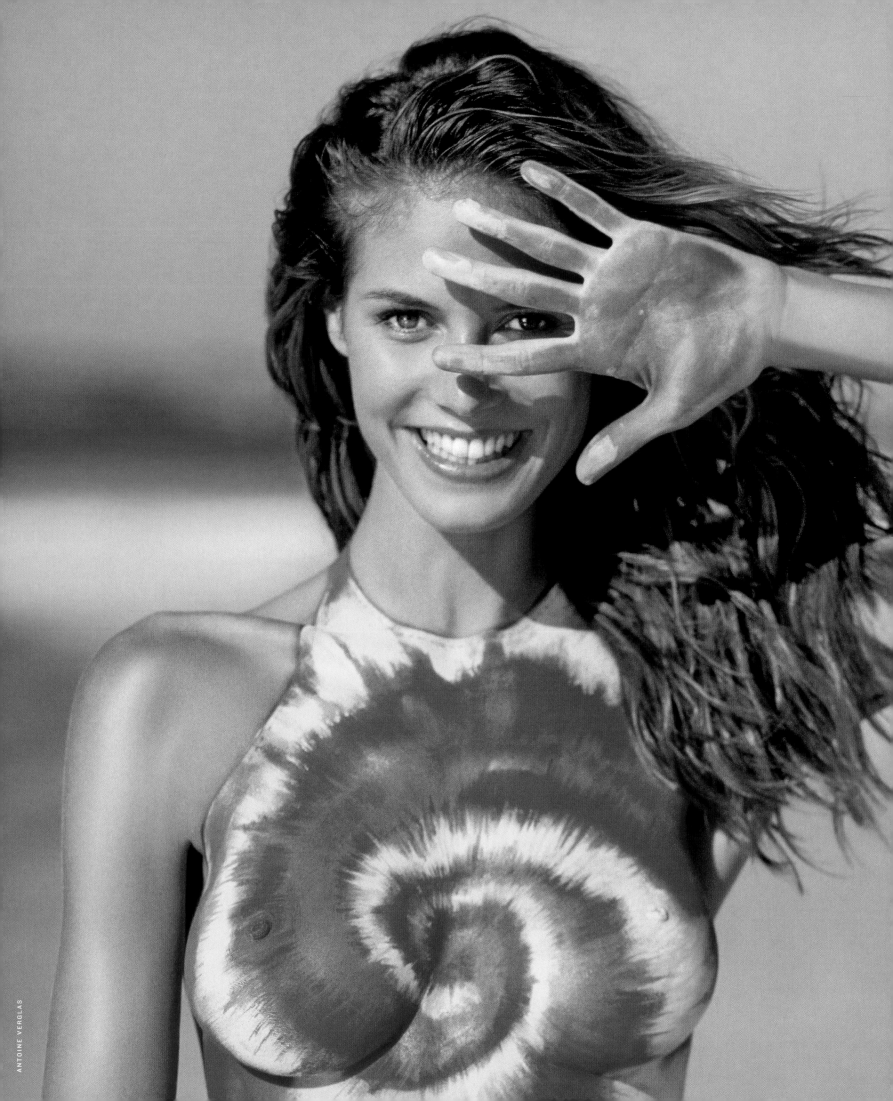

Sports Illustrated

In the PAINT

THE ART OF JOANNE GAIR

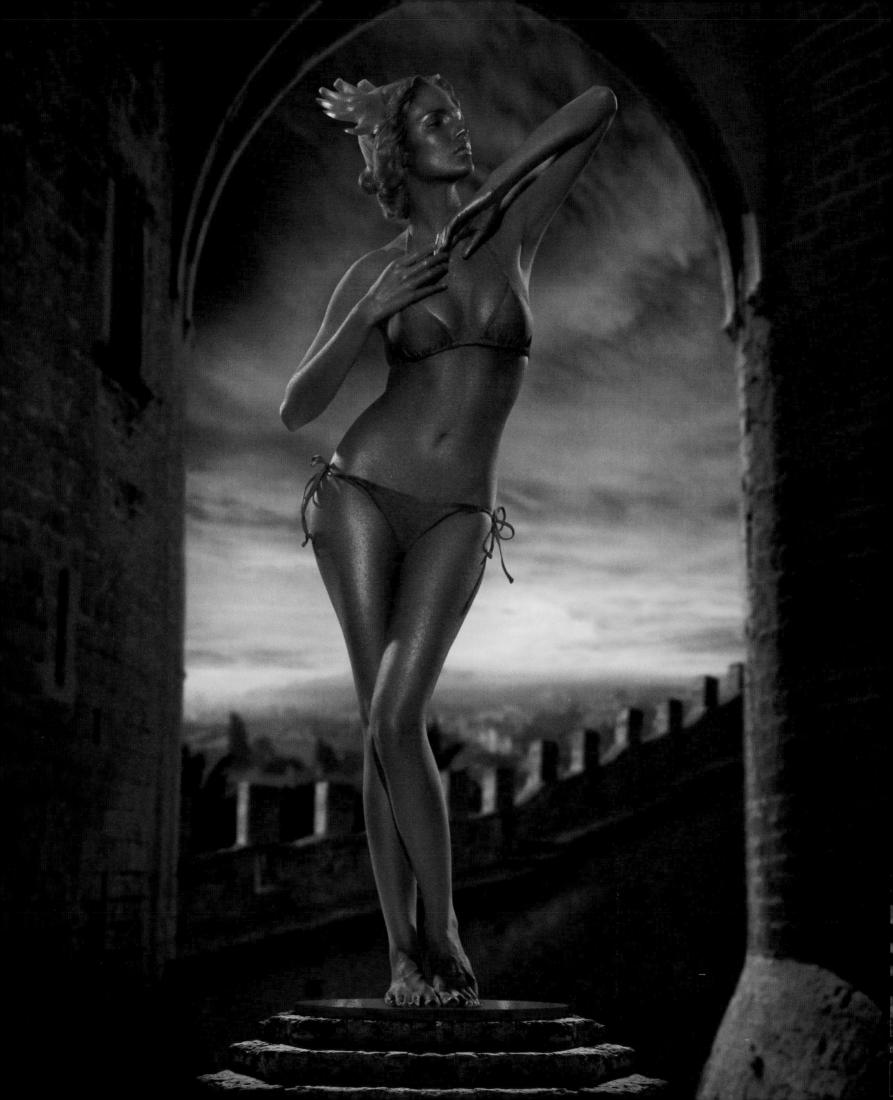

Contents

EDITOR
Rob Fleder

CREATIVE DIRECTOR
Steven Hoffman

ART DIRECTOR
Jay Soysal

SWIMSUIT EDITOR
Diane Smith

ASSOCIATE EDITORS
MJ Day
Jennifer L. Kaplan

COPY EDITOR
Kevin Kerr

ASSOCIATE
ART DIRECTOR
Josh Denkin

REPORTER
Adam Duerson

PREPRESS TECHNICIANS
Robert M. Thompson
Dan Larkin

RESEARCH ASSISTANTS
Lisa Blunt
Vanessa Kitchen

PHOTOGRAPH BY JAMES PORTO

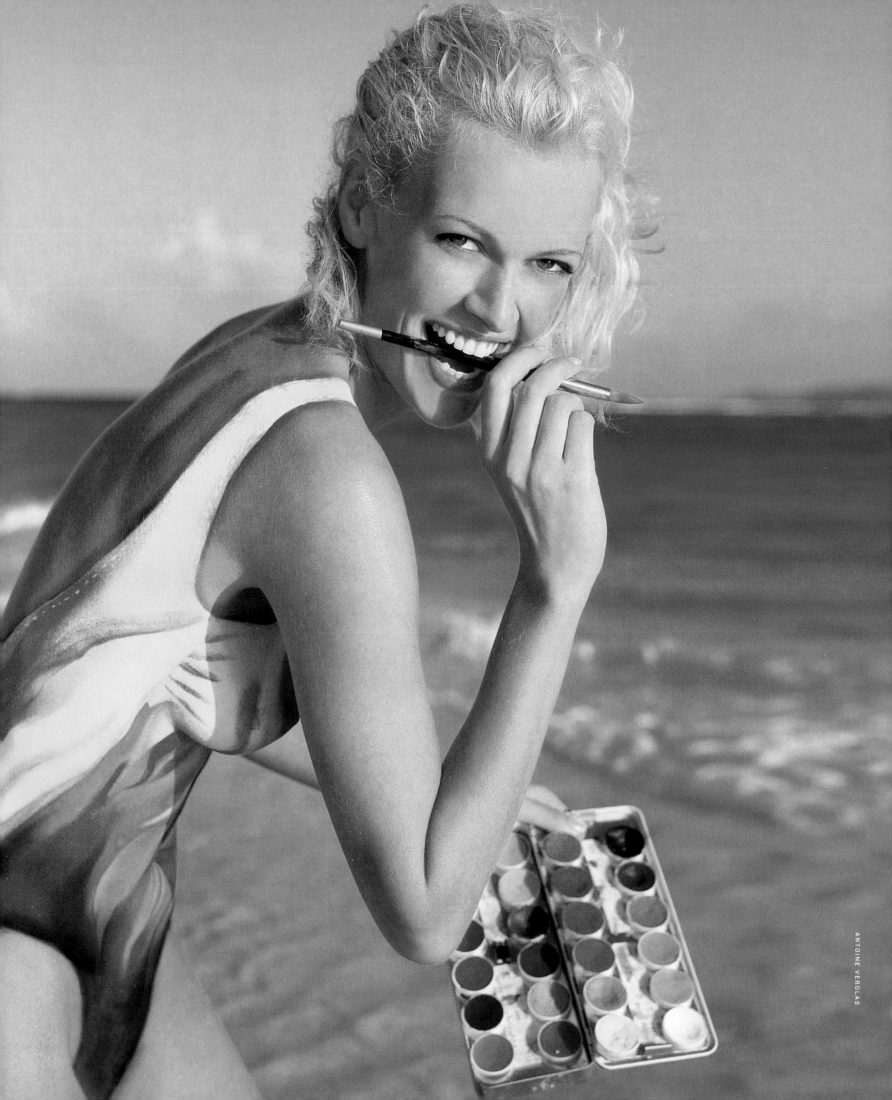
ANTOINE VERGLAS

INTRODUCTION

By L. JON WERTHEIM

ALL IT A TRUMP L'OEIL. FOR years, the SPORTS ILLUSTRATED Swimsuit Issue has been engaged in an arms (and legs and chests) race of sorts, an internal game of can-you-top-this? There had long been an unspoken expectation that, with each passing Swimsuit edition, the models would be increasingly ravishing, the locations increasingly mesmeric, the poses increasingly daring. "It was always the same situation year after year," says Swimsuit Issue editor Diane Smith. "*Hey, great issue. Now what in the world are we going to do to make the next one better?*"

Then, in 1999, the editors called Joanne Gair and dispatched her to Necker Island, Richard Branson's private retreat in the Caribbean. A self-taught makeup artist by trade, Gair was presented with the canvas of a naked body and—giving new dimension to the term "product placement"—was assigned to paint swimsuits onto the models. (Think Rembrandt with an unending supply of rubbing alcohol, tissues and depilatory wax.) The resulting images were simply stunning, equal parts exotic and erotic with an element of optical illusion thrown in for good measure. Assuming there existed readers who didn't look closely at the pictures, they could be forgiven for thinking that the swimwear was the genuine article.

The process is painstaking because of Gair's obsessive precision. Take a peek, for instance, at the minuscule air holes in the Sacramento Kings jersey in which Marisa Miller is "clad."

It became immediately clear to both the readers and voyeurs everywhere that these "skinscapes" were not only sensational, but insurmountably so. Thankfully, that fact did not elude SI's editors, so Gair's body painting is now as much a staple of the Swimsuit Issue as sand and cleavage. Gair's body of work—or is it work of body?—from the past nine years is displayed in these pages. Some of the images were created on majestic beaches, others in a Manhattan studio. Some replicate microscopic bikinis, others long-sleeve uniform jerseys. Some employ luminous colors, others make skillful use of shadows. Every canvas is unique—bearing its own topography, tone and temperament—but in each instance, the verisimilitude is striking. "Whatever idea we came up with, no matter how crazy, Joanne executed it," says Smith. "It really is genius at work."

Gair comes by her gift honestly. A native New Zealander, she grew up fascinated by the ways the indigenous Maori tribe expressed heritage through facial skin adornments. Plus, some of her fondest childhood memories are of four generations of her family skinny-dipping together, so "I grew up very comfortable with the human body—that's very much a part of who I am."

She moved to L.A. in 1984, and, seduced by the challenge of creating what she calls "the art of illusion through the medium of makeup," worked on album covers and music videos for the likes of Mick Jagger and Madonna. In the early '90s, she assisted the photographer Annie Leibovitz on a shoot of actress Demi Moore. Inspiration struck. *Why not have the makeup artist perform her handiwork on Moore's entire body?* With breathtaking exactitude, Gair painted a pinstripe suit onto Moore. When the image ran on the cover of *Vanity Fair*, Gair suddenly became to body painting what Picasso was to Cubism.

Although models often lament the rigors of their job—as if striking a pose is akin to working the blast furnace—sitting for Gair is genuinely grueling work. Even stashing brushes in her hair as she paints in order to save precious time, Gair can take as long as 12 hours to complete an image. And it's not as though you can step outside and grab a cup of coffee or duck out to the gym, while, say, a leopard skin bikini *(page 28)* is being applied to strategic portions of your torso. Ever try getting some meaningful sleep with delicate brush bristles dancing on your belly? "It was a trip," Heidi Klum once recalled of her initial body-painting experience. "Each time I'd open my eyes

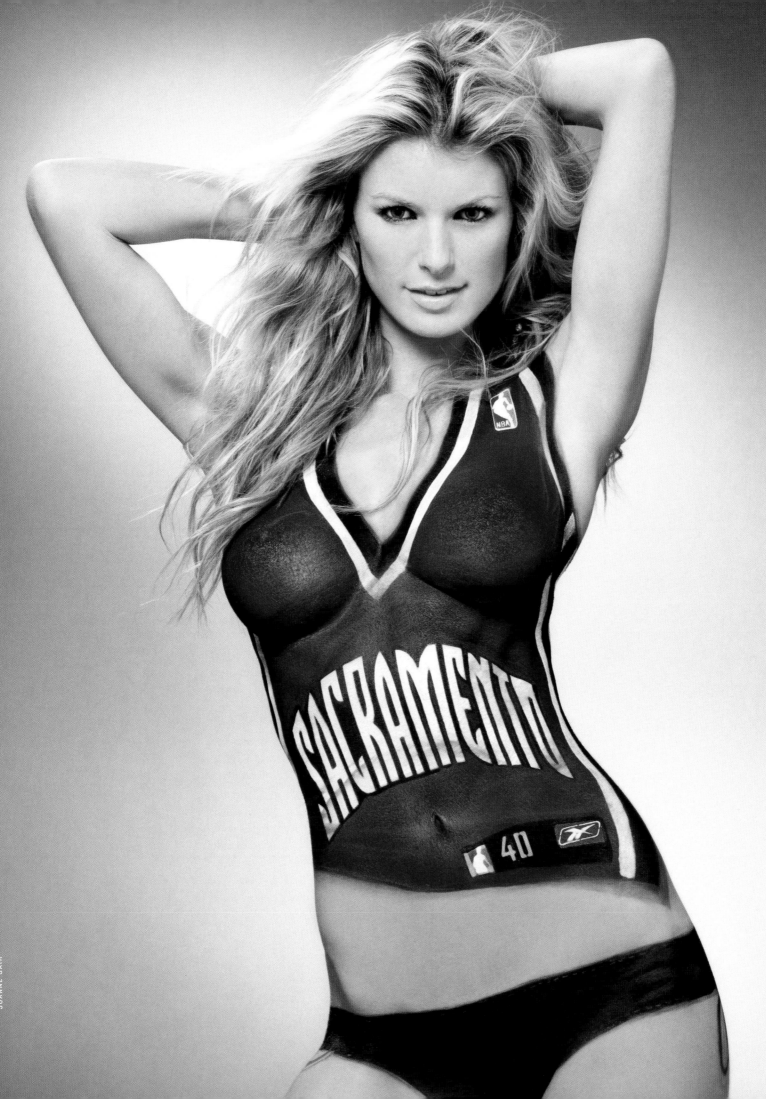

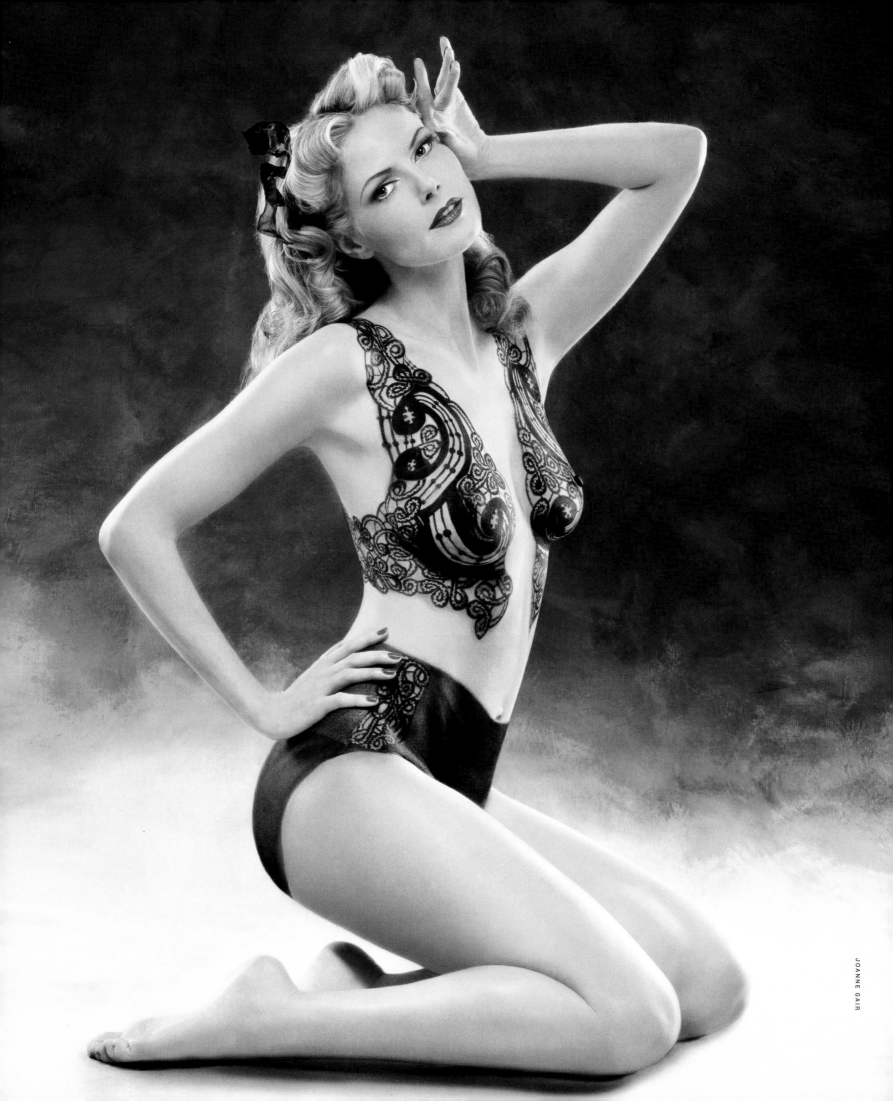

JOANNE GAIR

after one of those brief rests, Joanne would be much further along. It was as if a swimsuit were miraculously growing on my skin."

The process is painstaking because of Gair's near obsessive standards of precision. Every crease and stitch and fabric perforation and shadow and delicate texture is considered and meticulously accounted for. Take a peek, for instance, at the arresting image of Marisa Miller "clad" in a Sacramento Kings basketball jersey *(page 11)*, and note the minuscule air holes. When Gair painted the models as classical statues, she didn't merely aim for a bronze hue. She played alchemist until she found a tint that was a *weathered* bronze. "If you're not going to try to make it as real as possible, why do it?" Gair reasons. "At least that's my philosophy."

If God is in the details, so is the devil. On that initial Necker Island shoot, Gair used a water-based paint to create Klum's pink, yellow and red tie-dye one-piece. When Klum inadvertently wiped away some perspiration, the "suit" came off on her hand. Antoine Verglas had the presence of mind to snap a photo—published on page 4—that became iconic, an instant, just-add-water classic, so to speak. There was also the time Gair began working on Yamila Diaz's black chiffon suit at three in the afternoon in preparation for a sunset shoot. The work of applying three different layers and re-creating the puckered roses took longer than expected, so it was dark by the time they finished. No problem. Gair wrapped the precious rose petals in tissue so the "suit" wouldn't run. Like a cocooned insect, Yamila slept through the night and was photographed as dawn broke the next morning *(page 20)*. "That," says Gair, "ended up being one of my favorite bathing suits."

It was Man Ray who famously said that he painted "what cannot be photographed." Gair turned that notion on its head. In 2005 she armed herself with a Canon camera and, summoning her imagination and visual gifts, began to photograph her work. For three years running, her photography as well as her body painting has appeared in SI. "I call myself an image maker," she says. "I don't stop at the face or the body. I try to see the whole picture. I try to tell stories through my art."

The stories she tells in this book are eloquent and finely textured. They're enduring, too—even though a few drops of water could have dramatically changed the flow of the narrative.

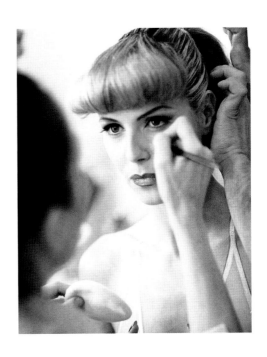

"Each time I'd open my eyes after a brief rest," Heidi said, "Joanne would be further along. It was as if a swimsuit were miraculously growing on my skin."

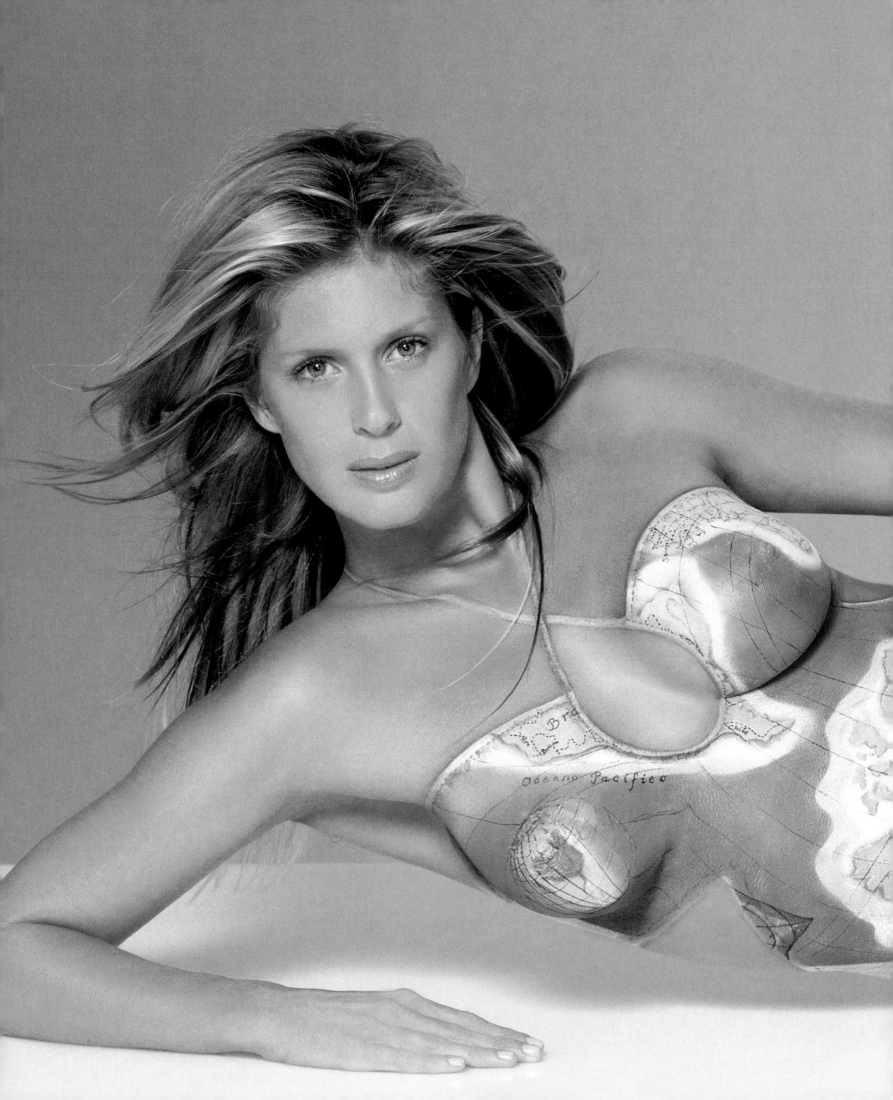

The Paintings >>

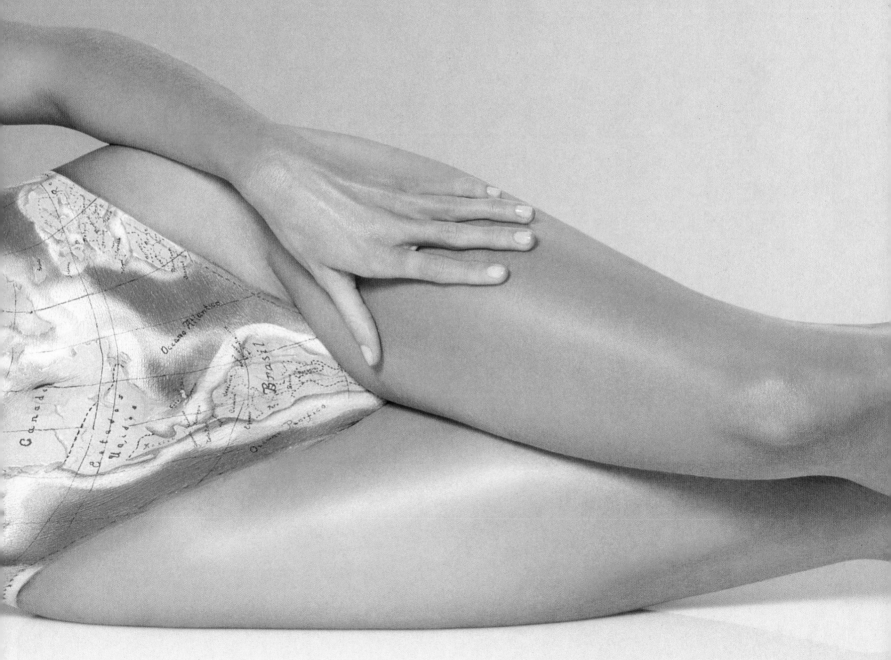

Photograph by MICHAEL ZEPPETELLO

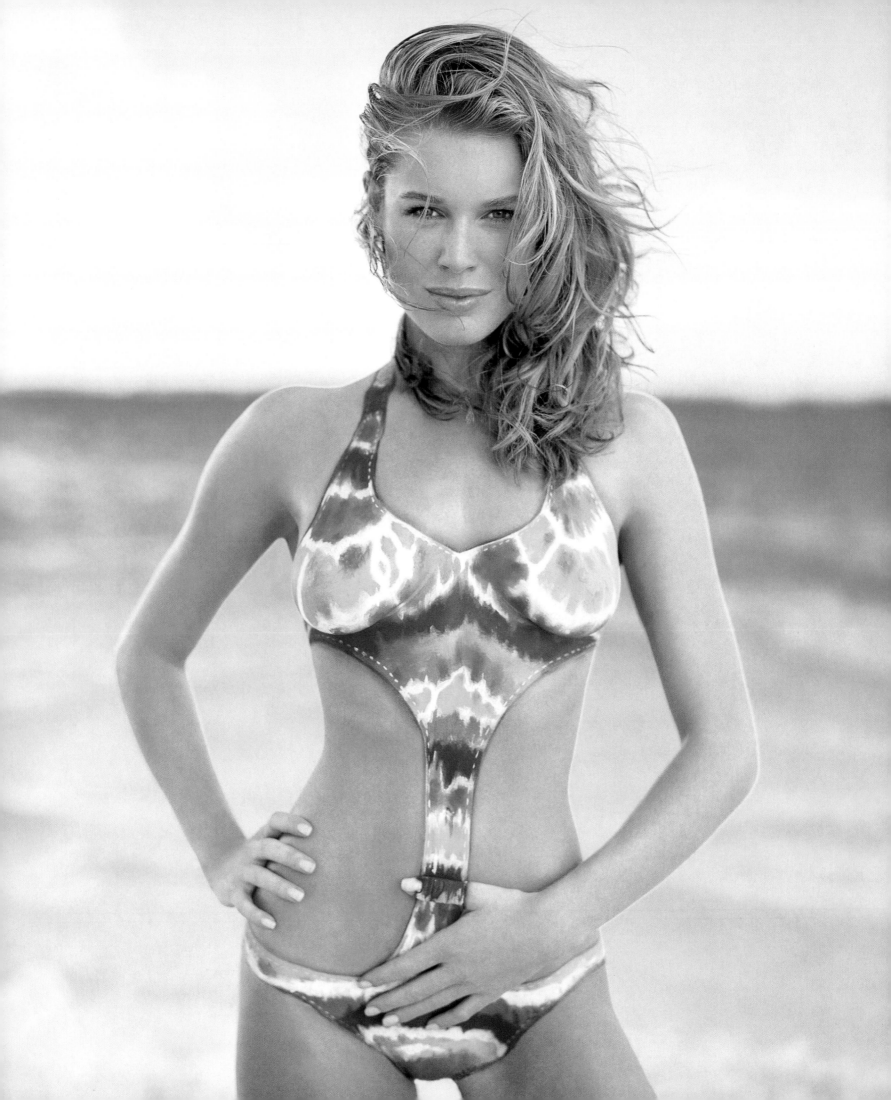

S

Benjamin Moore... OR LESS

Photographs by
Antoine Verglas

Some paint,
a little sun
and a great
deal of
pulchritude
leave very
little to the
imagination

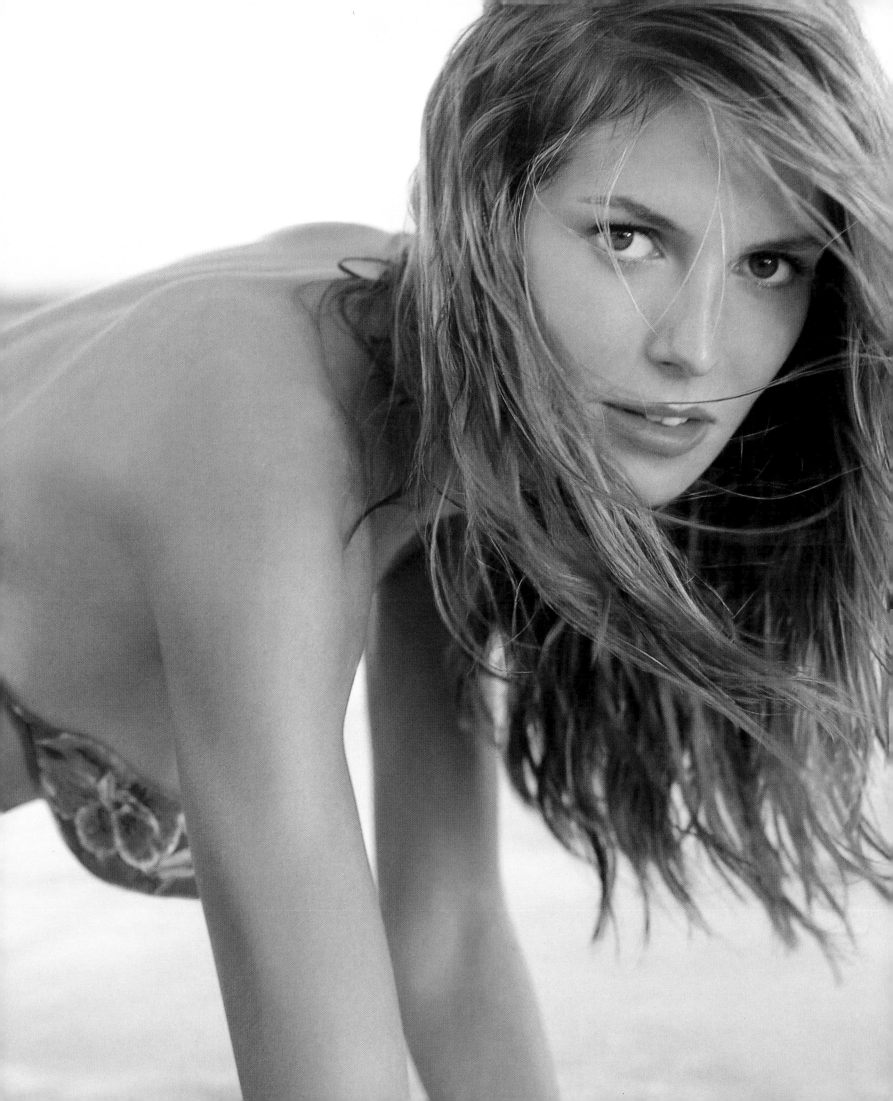

"The flowers took a long time to do, and when we finished the light was no good, so I had to sleep with the painting on. I had to lie on my stomach and try not to move while I slept, then we shot the next morning."

~ *Yamila Diaz*

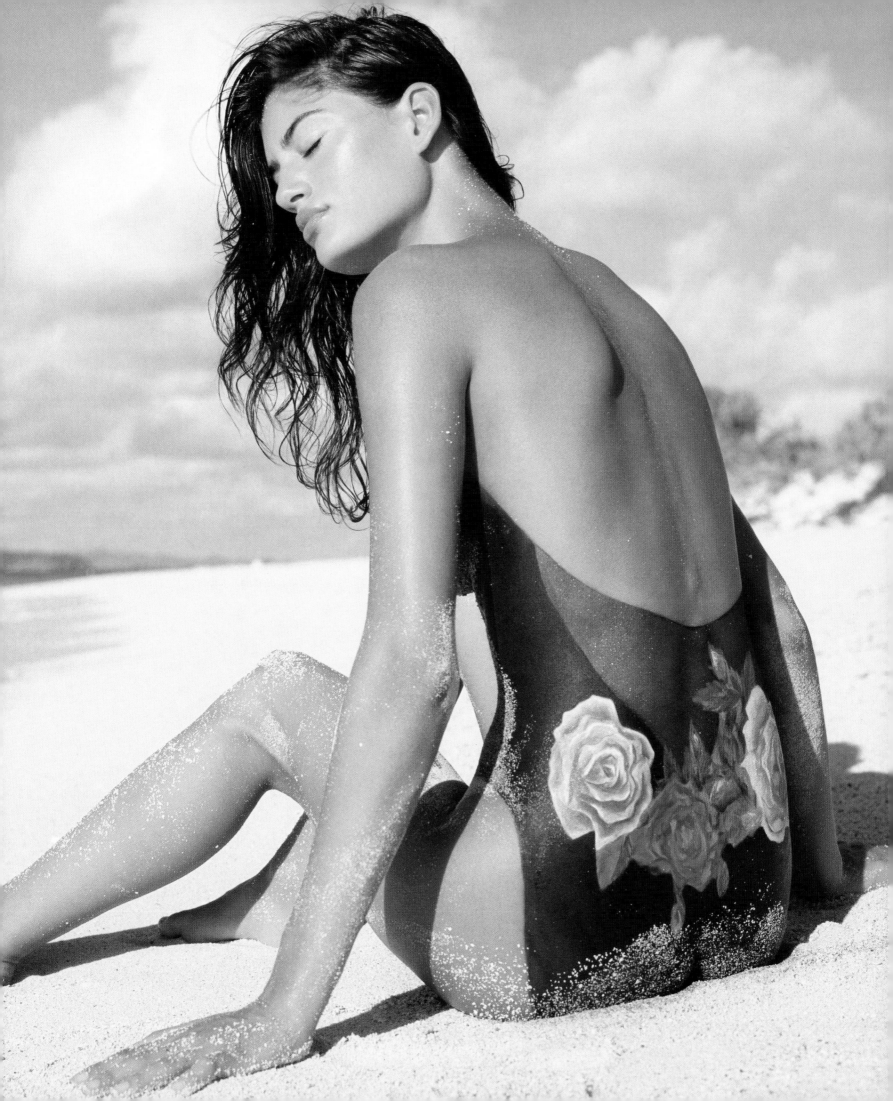

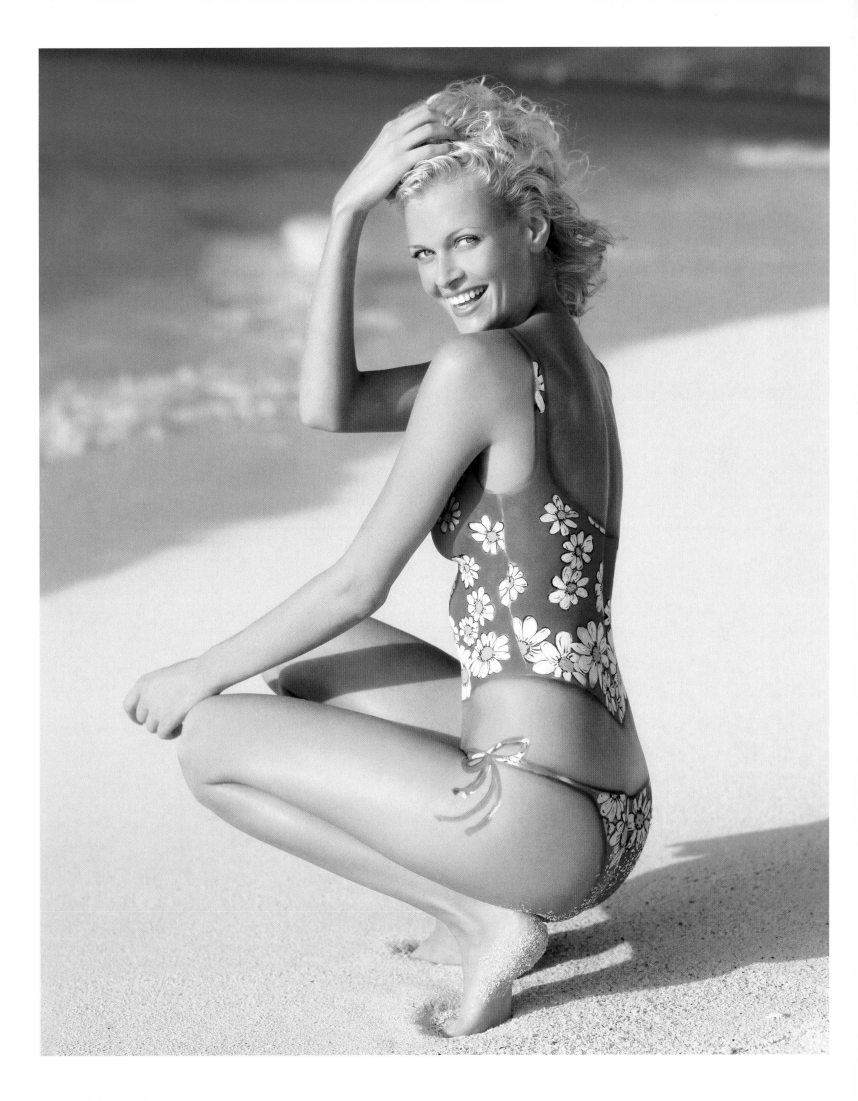

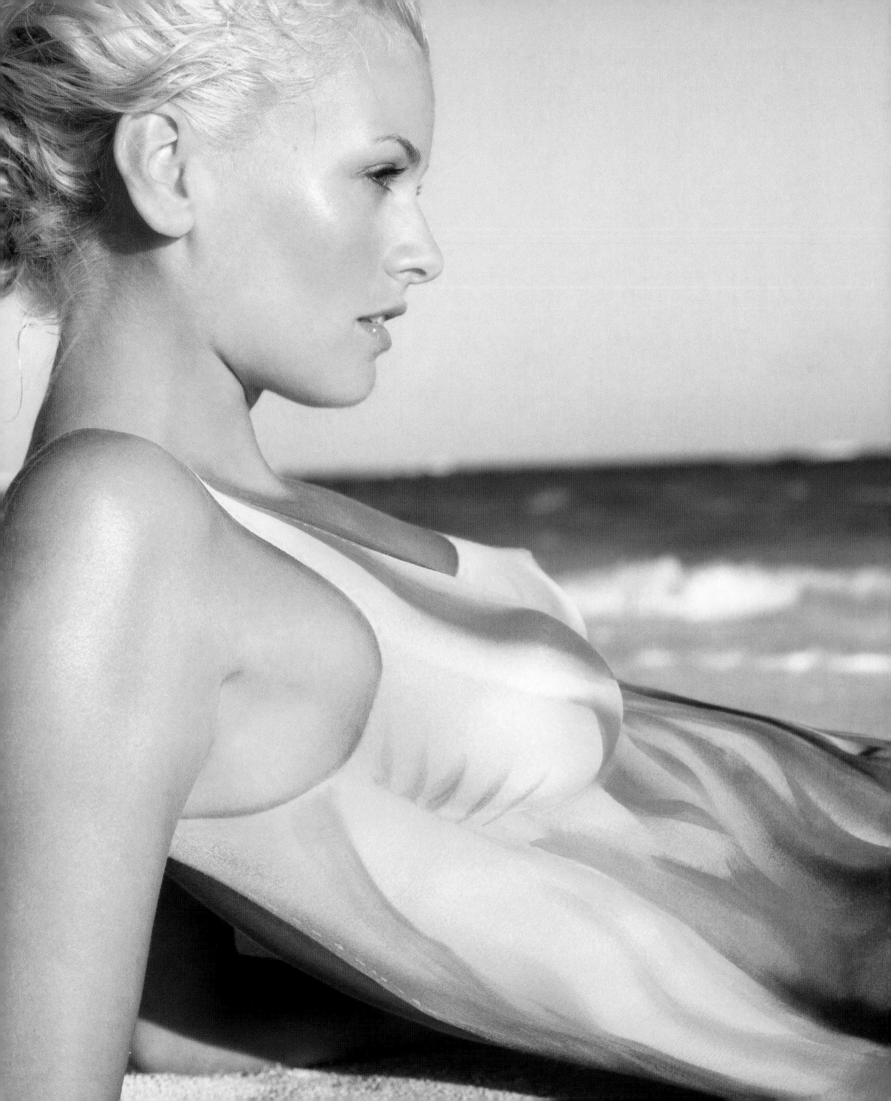

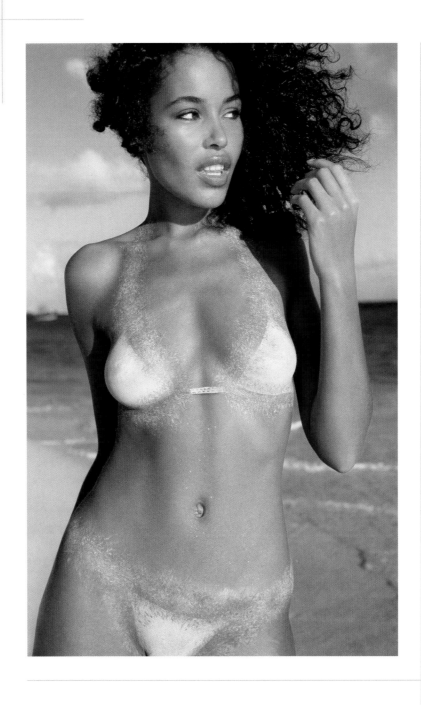

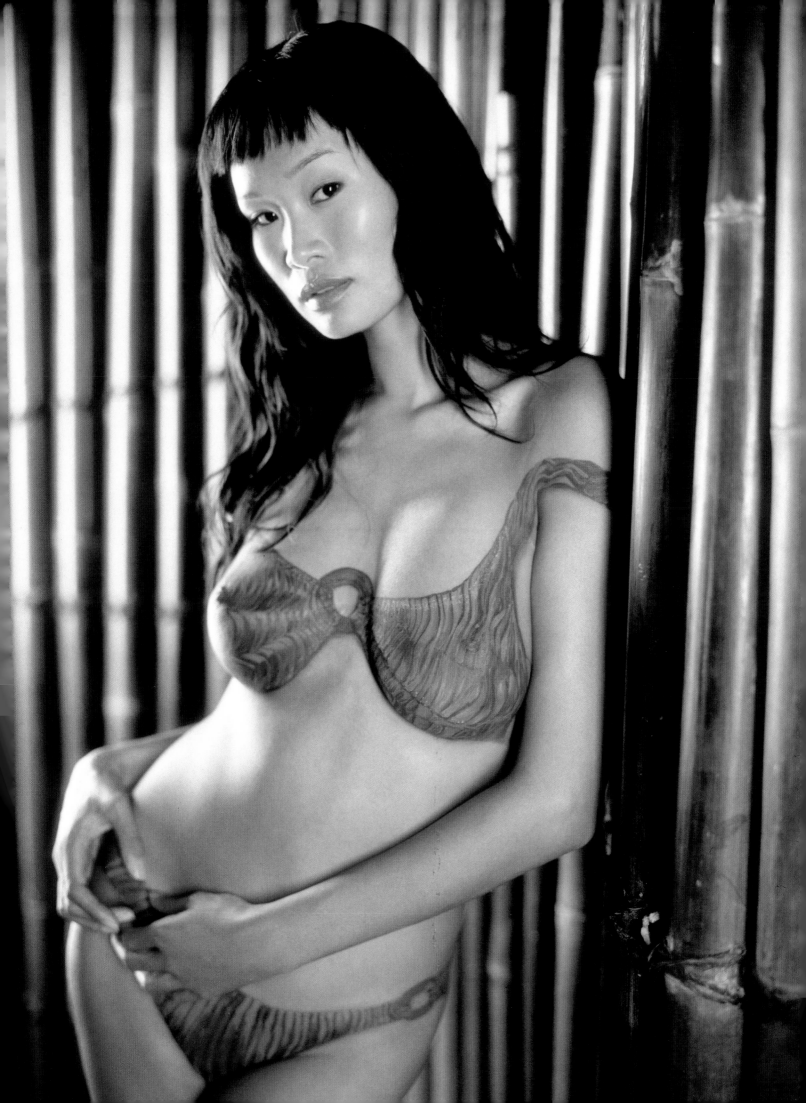

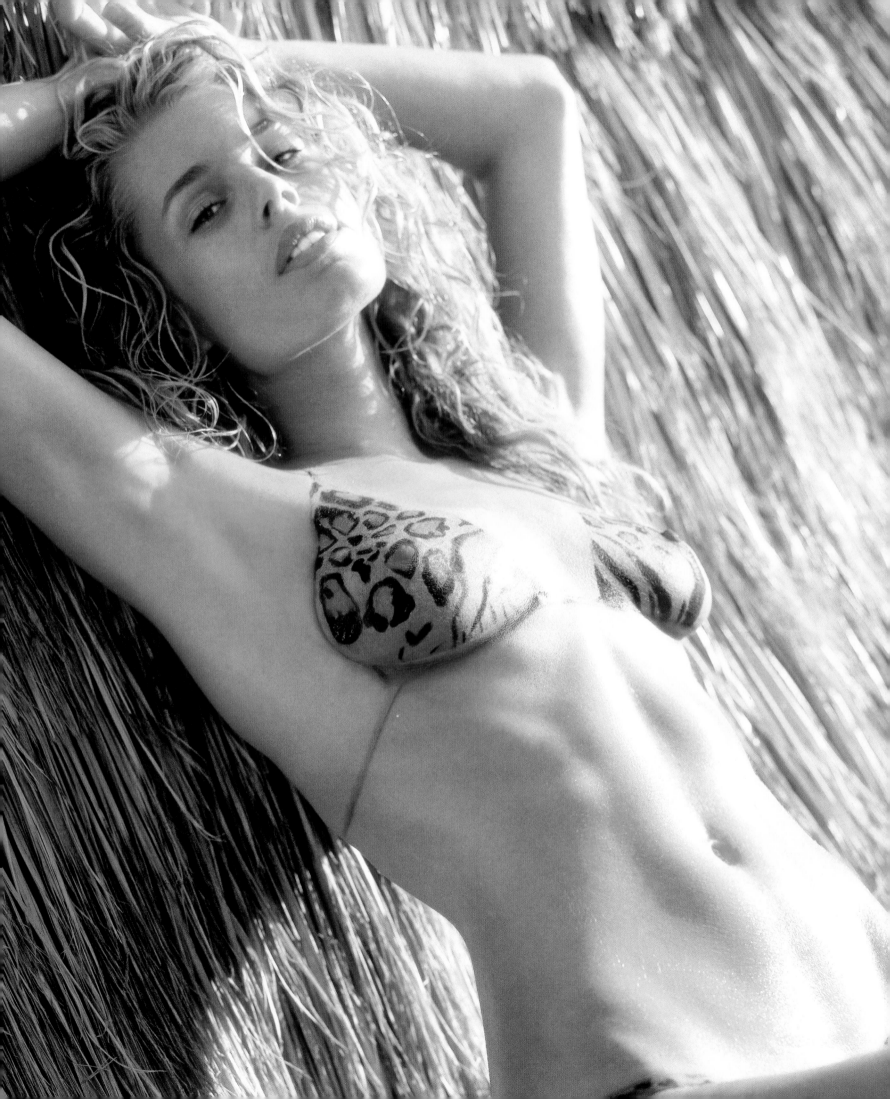

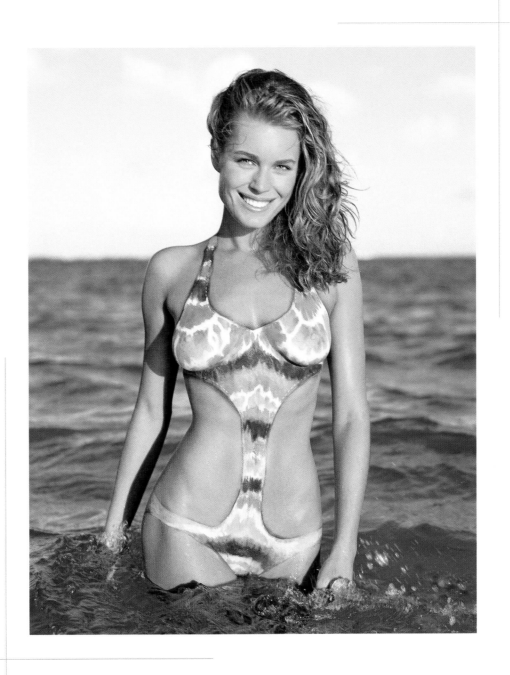

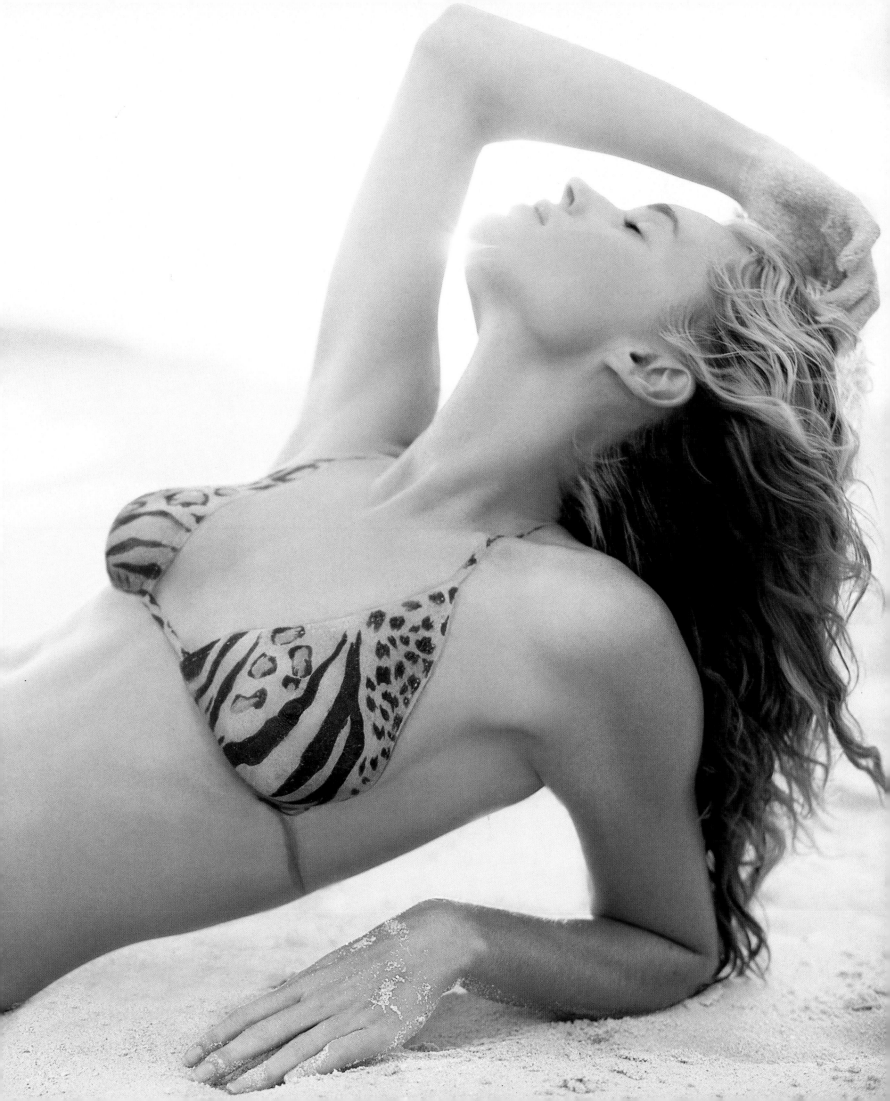

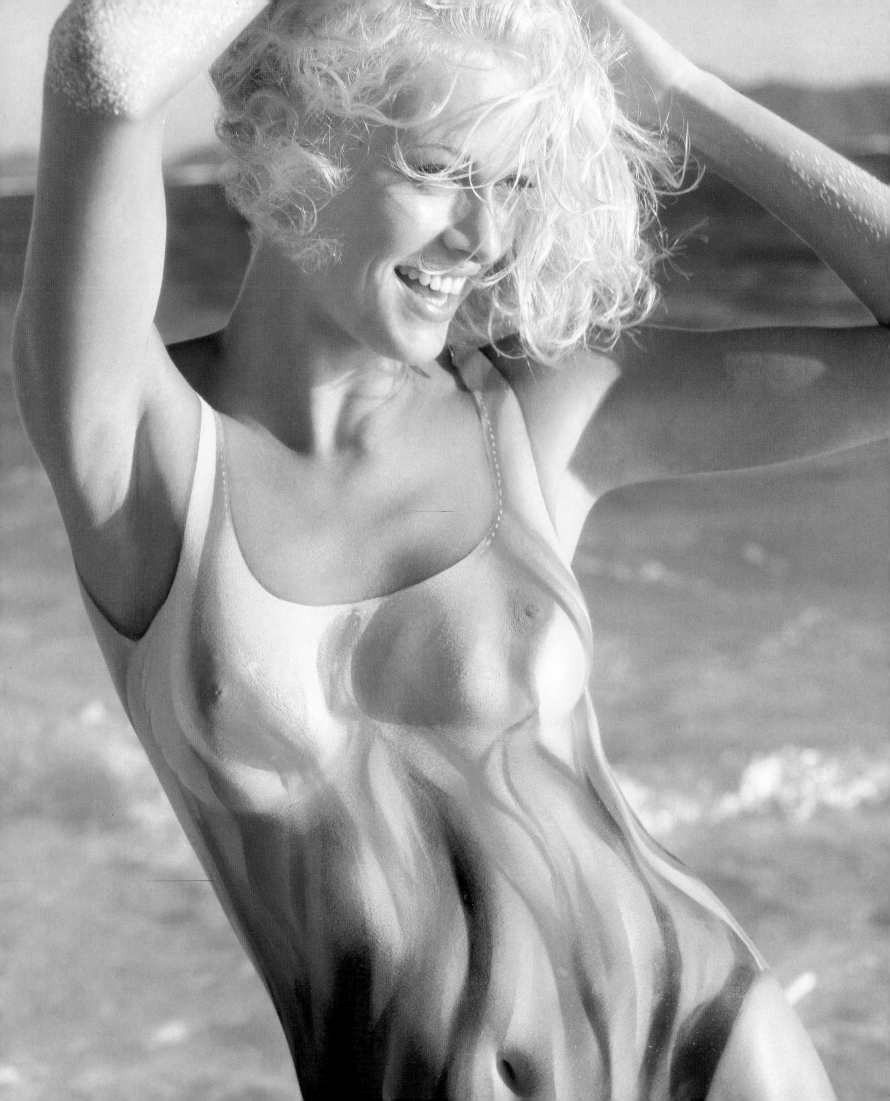

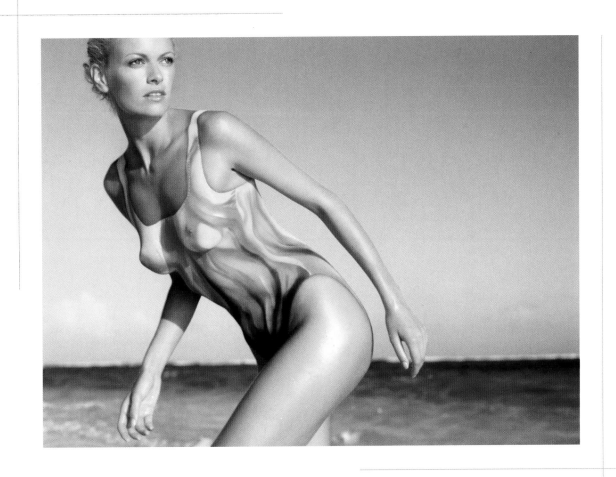

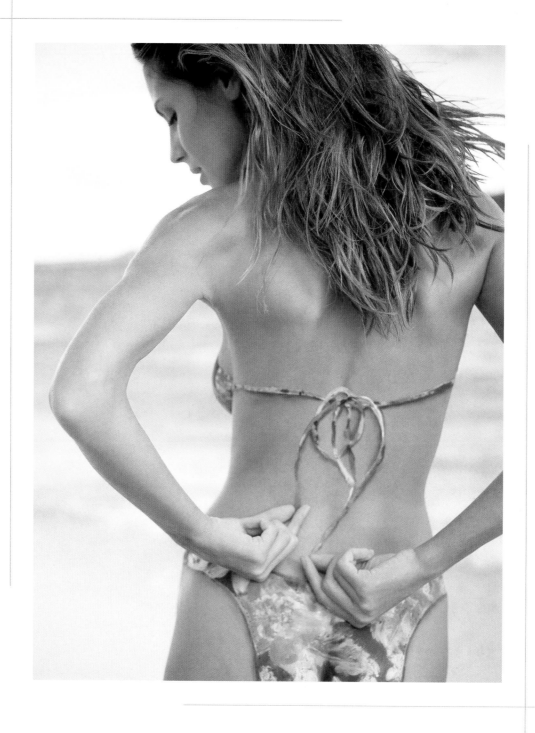

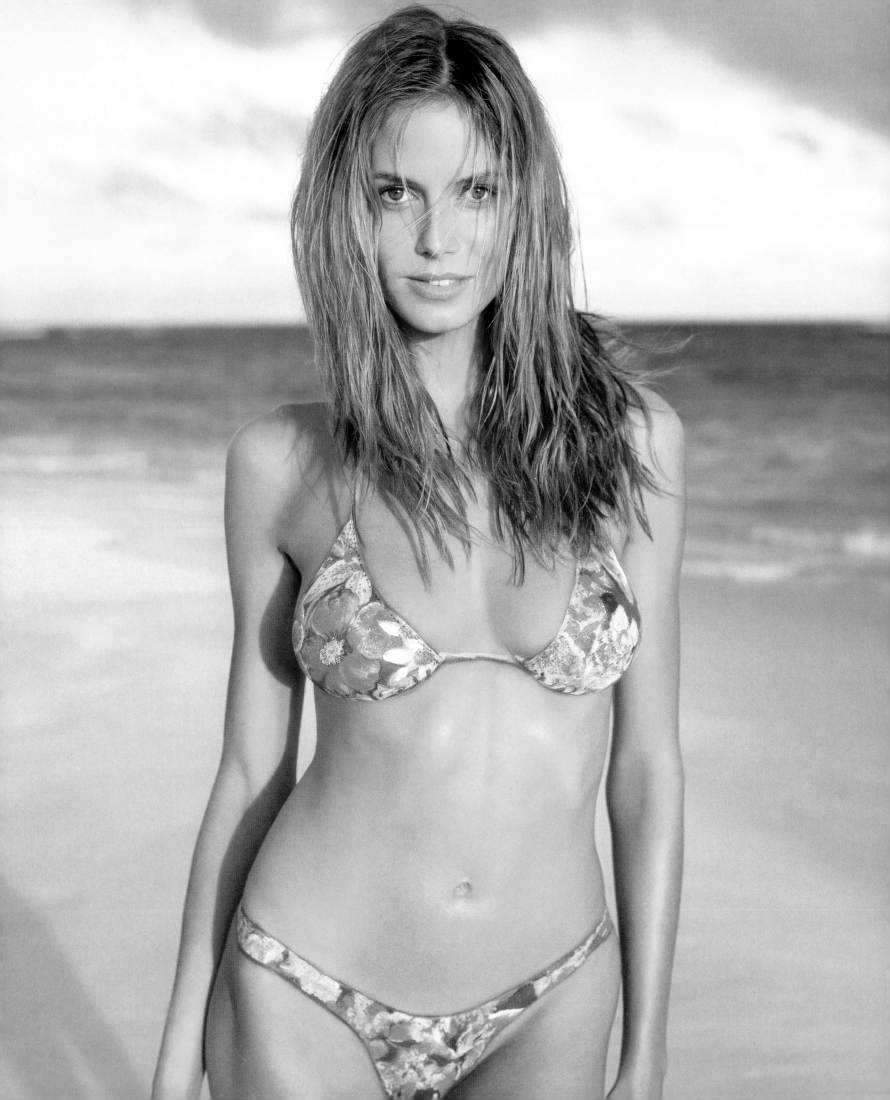

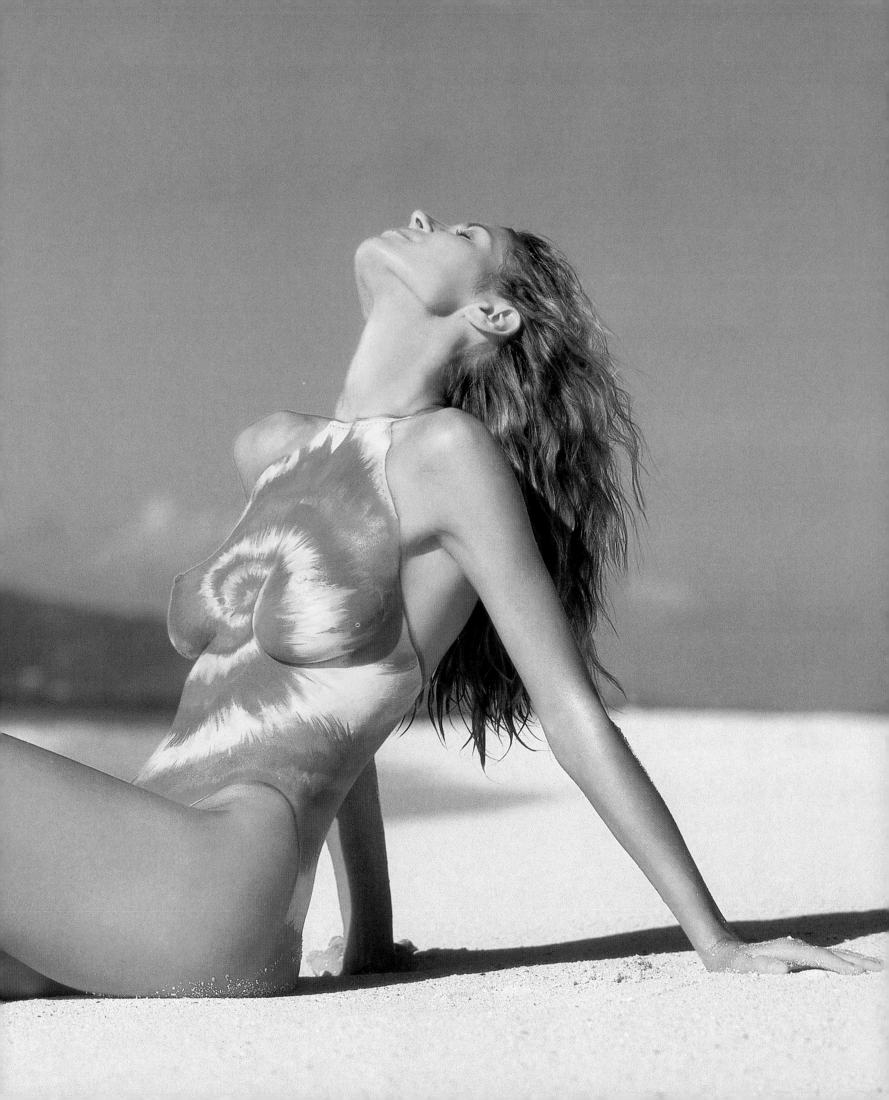

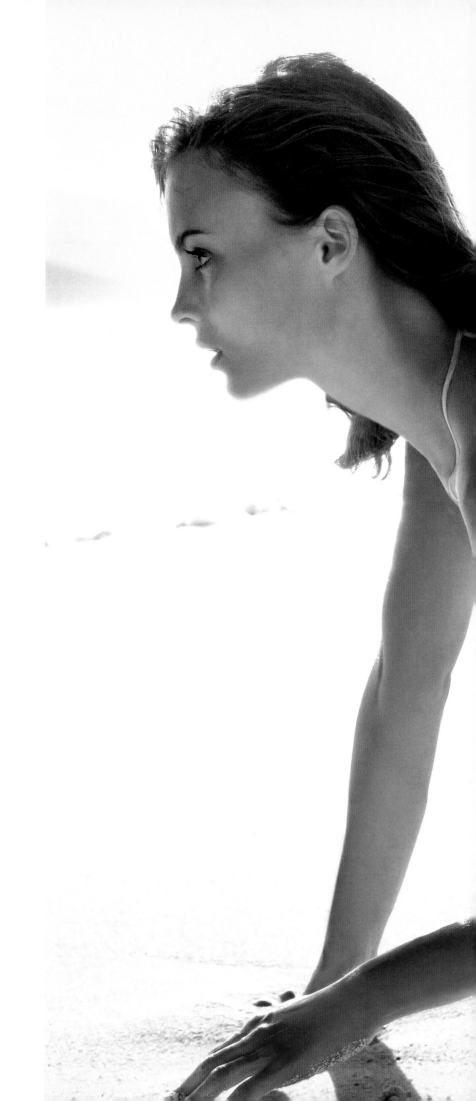

"I'm just a Kiwi girl that likes to color in. But when New Zealanders embark on something, we see it through until the end. I'm trying to paint something as picture-perfect as it can be."

~ Joanne Gair

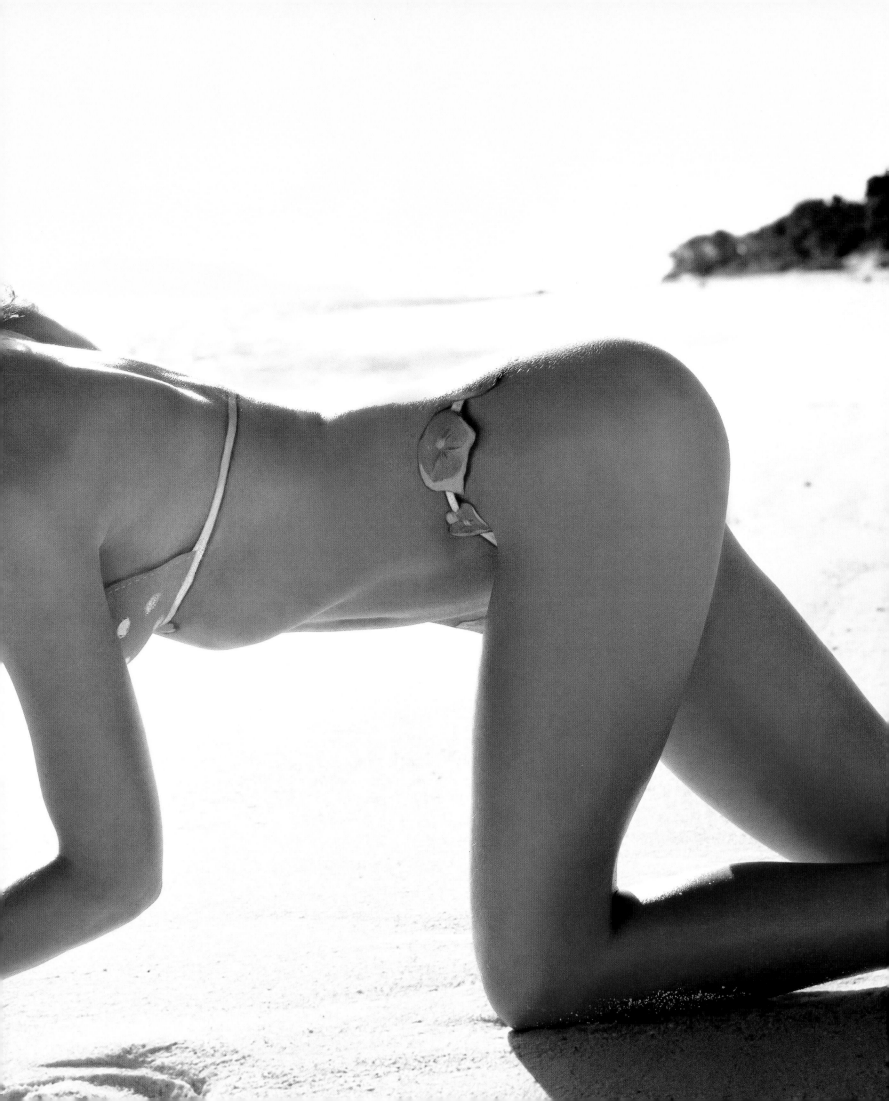

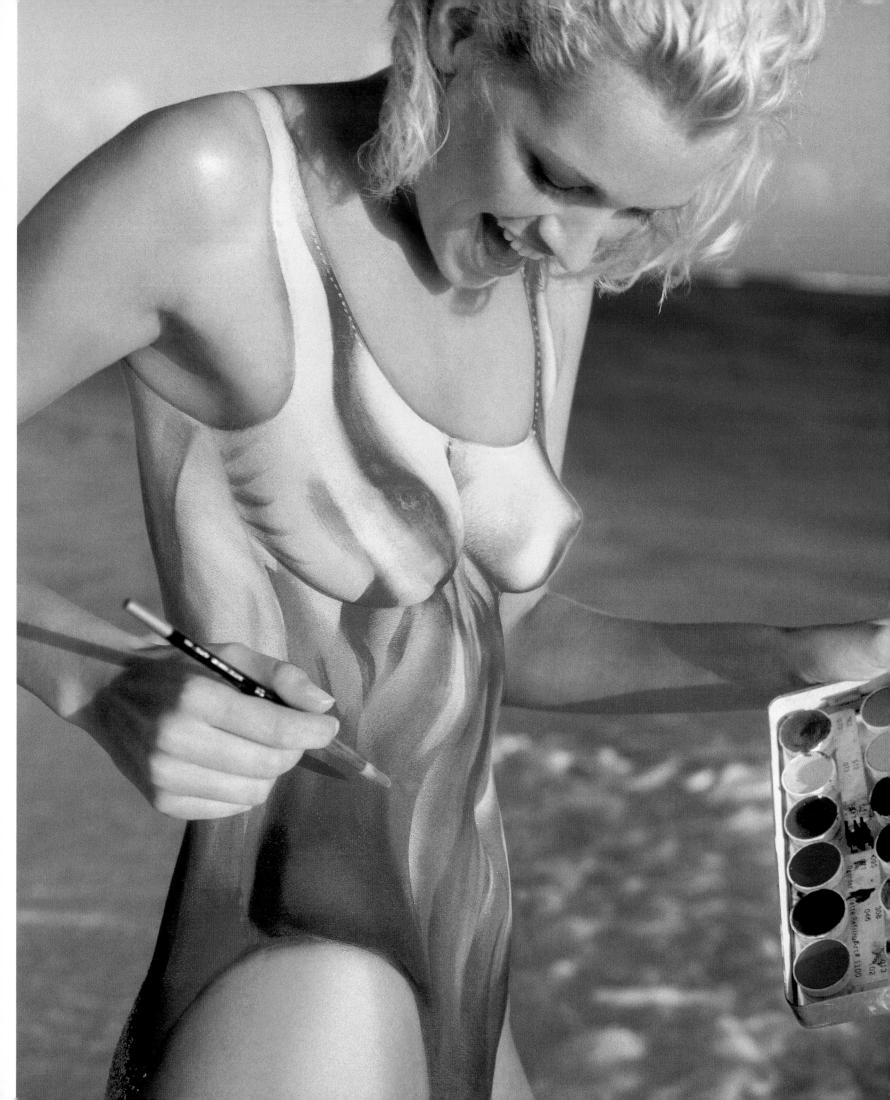

Paint by NUMBERS

WHAT DO YOU GET WHEN YOU MIX FIVE SUPERMODELS, ONE BODY PAINTER AND A REPORTER WITH A VERY SHARP PENCIL? WE'LL GIVE YOU THREE GUESSES *By Austin Murphy*

ROW UP. GET YOUR MIND OUT of the gutter. You make me sick. This is but a sampling of the scoldings I have meted out to some of my friends since returning from a long weekend in the British Virgin Islands. There seems to be this expectation among my mouth-breathing buddies that because I've seen several of the planet's most gorgeous women in their birthday suits—because, for example, Rebecca Romijn sat top-less beside me while eating scrambled eggs and fruit one morning—that I'm going to satisfy their lewd curiosity; that I'm going to share my memories, my precious and minutely detailed memo-ries, of their unclothed bodies.

I'll tell you what I told them: This is a story about body painting. My as-signment was to travel to Necker Island and steep myself in an emerging art form. I would have serious discussions with Joanne Gair, the world's preemi-nent body painter, about her brushes and pigments. We would talk about shadowing and highlighting, about the smearing and running challenges posed by friction, perspiration and tropical humidity.

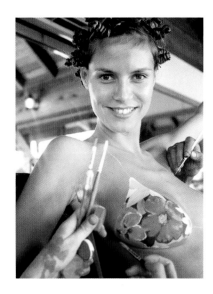

It was up to me to maintain my professionalism. I confess, however, that at times—such as when Heidi Klum stood topless before me poolside—it was a little hard.

If, in the course of my research, I found myself in close proximity to nude and nearly nude supermodels, it would be up to me to maintain my professionalism. I confess, however, that at times—such as when Heidi Klum stood topless before me poolside, briefly massaging my scalp, remarking in her vaguely Germanic accent, "Austin, we have the same kind of hair"—it was a little hard.

Necker Island is the silly and slightly suggestive name of Richard Branson's 74-acre private resort. It shall henceforth be referred to in this story as the Island of the Naked Supermodels.

Here's how you get to the Island of the Naked Supermodels: 1) Have your editor assign you to write a story on body painting; 2) fly to Miami, connect to San Juan, board a turboprop for Beef Island, then settle in for the jowl-flapping, 30-minute cigarette-boat ride to Branson's paradise; 3) once on the island, which these days rents for 20-plus grand a night, frequently remind yourself, *This is not a dream.* I avoided depression by not reflecting on the fact that the only way I would ever return would be if I were reincarnated as a gecko.

Gair is an internationally known makeup artist who also happens to be the world's most sought-after body painter. For the next few days in October, her canvasses would be the celestial bodies of the SI swimsuit models. She is a genius, a hoot and a hyperpatriotic New Zealander. Upon arriving on the island, where the staff is run by an Australian couple, she jokes that, as a Kiwi, she expects to receive inferior service. Asked where in New Zealand she's from, she replies, "Takapuna—the Puna end of Taka, actually." She has a good laugh at this bit of Kiwi humor, then remembers with a start that she must call home to find out if her father, the longtime mayor of Takapuna, has been reelected.

No time for that now, though. It is late Friday afternoon and there is a conference to preside over, trouble to be shot. Clustered at the north end of an enormous teak table in the breezeway are, among others, Rebecca, the model Gair will paint first, photographer Antoine Verglas and SI creative director Steven Hoffman.

The conference has been convened to make the final selection of suits that Gair will re-create on the supermodels. Gair is crazy about the pastel bikini-and-shirt combo she's going to paint on Rebecca, but Hoffman wonders, "Is it sexy enough?" To find out, he asks Rebecca to model the ensemble for us. When she emerges from the changing room, spontaneous applause erupts at the table. I find myself biting down on the first knuckle of my right forefinger and recalling the parting advice of my wife, Laura: "Try not to make too big an ass of yourself," she said. "And remember that these women have not had children."

"What do you think, Steve," I say. "Is it sexy enough?" The question is rhetorical: Right now, the sight of Rebecca would be a serious risk to the health of any man on heart medication.

"Before it was on the table," says Hoffman, a tad defensively. "Now it's on *her.*"

As Rebecca stands before us, Gair notices a payload problem. The left cup of the model's bikini top is not quite up to the task of containing the model. "See how the left breast is showing underneath?" says Gair. *Gee, now that you mention it, Joanne, I do.*

"I like that," she says. "We can use that. It makes it more real." She likes it because that's exactly how she'll paint it on Rebecca. "Details

like that are important," says Gair. "Seams are important. Bunching and puckering is important."

I realize that alibis will also be important, so I scribble these phrases down; they will be my best friends on the island. However genuine my passion for body painting, it seems inevitable, when face-to-face with these voluptuous young women, that my gaze will occasionally wander. If caught ogling, I will rhapsodize about the amazing verisimilitude of the bunching, the trompe l'oeil-like effect of the puckering.

SATURDAY MORNING Antoine wants to be shooting at first light, which means poor Rebecca got a 1:00 a.m. wake-up call. She is incredibly game. The painting is taking place in the island's air-conditioned gym. Between 3:30 and 5:30 a.m., Rebecca lies on her back, held in place with pillows, catching a few fitful z's while Joanne and her assistants, Jesse Tipare and Ramon Espinosa, work on her with air nozzles, brushes, Q-tips and the occasional towelette.

I show up for my initial interview at dawn, as per our agreement. To assure Rebecca that I am not simply a gentleman, but a gentleman *solely interested in the emerging art of body painting*, I conduct the interview with my back to her. I sit facing a rack of dumbbells.

A.M.: "Rebecca, were you able to get any sleep on that table?"

R.R.: "Some. I had all these weird dreams. I was kind of alternating between moments of tranquillity and self-consciousness, when I'd wake up and realize, Hey, I'm lying here butt naked!"

A.M.: "Rebecca, do the paintbrushes tickle?"

R.R.: "Only when they painted my belly button. That tickled big time. It woke me from a dream."

I'll spare you the substance of my dreams on the Island of the Naked Supermodels. Suffice it to say that when a staff member recounted for me how the main house had been built with dense beams imported from Brazil—"We've got some serious wood here," he told me—I empathized completely.

Joanne had predicted it would happen, and she was right. The more paint they slather on Rebecca, the less naked she feels. This casting off of inhibitions occurs with all the models, and is, to my mind, a great thing.

What distinguishes Gair from other body painters is her gift for capturing details that make the suits look real, duplicating shadows, highlights and those blessed puckers. Because the outfit she is now painting on Rebecca is extraordinarily intricate, the process takes 12 hours, much longer than anyone expected. To do my part to keep Rebecca's morale up during her ordeal, I pay her frequent visits throughout the morning. It is the least I can do.

When I next pop into the gym around 7:45 a.m., Rebecca and I talk about her recent marriage to actor and musician John Stamos, her new job hosting MTV's *House of Style* and her highly efficient metabolism. I take care during this conversation—indeed, for the duration of my stay on the island—to follow Jerry Seinfeld's advice to the cloddish George, who once got in trouble for staring too blatantly at a woman's cleavage: "It's like the sun," lectures Jerry. "You glance and look away."

Around midmorning, while on my way to the gym for yet another interview with Rebecca, I walk past the pool, where a dark-haired, se-

I take care during this assignment to follow Jerry Seinfeld's advice about staring too blatantly at a woman's cleavage: "It's like the sun," Jerry said. "You glance and look away."

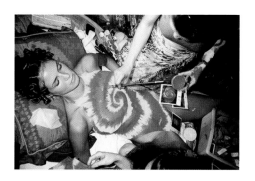

Joanne Gair was right when she predicted that the more paint she applied to models, the less naked they'd feel. This casting off of inhibitions occurs with all the models and is, to my mind, a great thing.

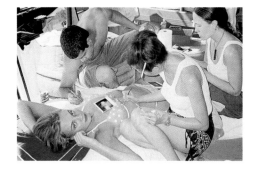

riously handsome man is floating on a raft. We exchange smiles. He is John Stamos, the guy Rebecca married three weeks earlier.

"Duty calls," I trill, holding up my notebook.

"No problem," he says. "But when you get home, just remember to send me some naked pictures of your wife."

I recount this exchange to Laura on the phone that night. "He should be careful what he wishes for," she says.

SATURDAY AFTERNOON Down at the dock, the cigarette boat from Beef Island discharges its cargo of unearthly pulchritude: Heidi Klum and Yamila Diaz are in the house. Klum you may recognize from last year's Swimsuit Issue cover or from her recent appearances on *Spin City*. Diaz is a 22-year-old Argentinean who is off to Miami on Tuesday for a Victoria's Secret shoot.

At lunch I find myself seated next to her—find myself seated next to her because I sprinted around the extrawide, 42-foot-long banquet table and flung myself into the unoccupied chair to her left. When I catch my breath, I ask her about the volatile currency in her native country. I am pleased with this conversational gambit. Yes, I am a sportswriter, it suggests, but one with a command of current events; one with compassion for his troubled neighbors to the south.

"Maybe you mean the Brazilian currency," says Yamila, who studied economics at the University of Buenos Aires. "The currency in Argentina is fairly stable."

SATURDAY EVENING I'm shooting pool with Peter Franchella, the cameraman for the crew filming the upcoming SI video of the swimsuit shoot. The humidity makes the cue grippy in my left hand. Peter is having the same problem. We look around, but can't find any talcum powder.

Twenty feet away is a fully stocked bar, behind which stands a lovely staffer named Kathryn, who comes around every 10 minutes or so to see if we'd like another cold one. Ten feet to our right, supermodel Audrey Quock is stretched out on her back, posing for Antoine. She is wearing about half a shot glass of turquoise paint.

"No talcum," says Peter. "This place sucks."

SUNDAY MORNING A bit of worship being in order, I follow the Three Flabby Guys—as the SI video crew has dubbed itself—in their migration toward the pool. They know something. Producer Ken Pisani has received intelligence that Heidi intends to do a bit of sunbathing this morning. We make it our business to be ensconced at the pool before Heidi arrives, then have the nerve to pretend to be pleasantly surprised when she does show up. As Heidi selects a chaise longue and peels off her top, I resist the urge to turn and high-five Ken.

Soon the heat drives all of us into the pool, where Heidi reigns like Cleopatra on the Nile, her barge an inflatable crocodile. I am treading water in the deep end while trying to hold up my end of the conversation—"You're from Cologne and you've never been to a WLAF game?"—when she makes a generous offer: "Austin, do you want my crocodile?"

I am touched by this small kindness, even though, by all appearances, she has no need of a flotation device.

Having taken enough sun, Heidi retreats to her room. To avoid giving the appearance that we'd been hanging around the pool solely to ogle her, we wait 30 seconds or so before packing it in ourselves.

Inside, I walk past Audrey, who is back in her civvies, having rinsed off the turquoise bikini. "Audrey!" I exclaim. "Almost didn't recognize you with your clothes on."

"How much longer is this creep going to be on the island?" she asks. (Actually, she laughs and says, "Weird, isn't it?")

Weird and wonderful. While immersing myself in the exciting world of body painting has been stimulating, I'm getting just as big a kick out of the quotidian moments of life on the Island of the Naked Supermodels: Yamila drawing me a little map and giving me a lesson in the geography of South America; Audrey rubbing sunscreen on my back; watching a topless Heidi gambol unself-consciously in the surf. True, the Flabsters and I witness that last vignette from a distance of roughly one mile, through the resort's powerful telescope, but it feels like we were right there with her.

Our recreational options are endless on this magnificent day: We can snorkel, water-ski, go deep-sea fishing, play tennis, basketball, or simply vegetate on one of the island's four beaches, each of which features a refrigerator stocked with you-name-it. Naturally, Peter and sound-man Adam Zebersky fire up the big-screen HDTV in the main house to watch *The Empire Strikes Back*. At one point Zebersky says, "They don't make movies like this anymore."

Before dinner, my assistance is required on the pool deck, where Yamila is being photographed in a black one-piece that Gair has tarted up with three roses across the model's lumbar region. My job is to hold one of the lights.

Working with lights isn't part of my job description, but I keep my mouth shut. If some of us didn't go above and beyond the call, they'd never get the damned Swimsuit Issue out. Antoine has Yamila posed on all fours in a little brook that babbles from the main house to the pool. Even though she is nude not 10 feet from me, even though I could stare undetected from behind my light, I do not stare. I refuse to press my advantage for the same reason Tour de France winner Marco Pantani refused to attack during a mountain stage last summer when defending champ Jan Ullrich punctured a tire: It wouldn't have been sporting.

Instead, I glance and look away, glance and look away. To this day I can close my eyes and see Yamila playing saucily to the camera. I can see the roses on her lovely back: one red, two pink. I can see that she is a bit chilly.

MONDAY MORNING With my customary "Everyone decent?" I barge into the gym at 5:15, where Yamila's backside is being retouched. She is leaning forward against a mirror, forming a breathtaking, lower-case *r*. She is light years from decent.

"Just came down to say my proper good-byes," I bluster. In the smile Yamila flashes me, I discern skepticism. Busted.

Busted but unrepentant. Moments from now I will board the waiting cigarette boat and forever take my leave of the Island of the Naked Supermodels. Don't condemn me for choosing, at the last minute, to stockpile a few more Yamila-related memories.

Come to think of it, don't ask me to share them, either.

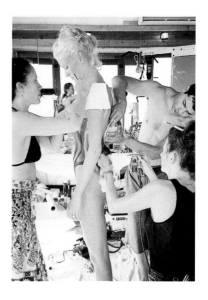

What distinguishes Gair from other body painters is her gift for capturing details that make the suits look real, duplicating shadows, highlights and those blessed puckers.

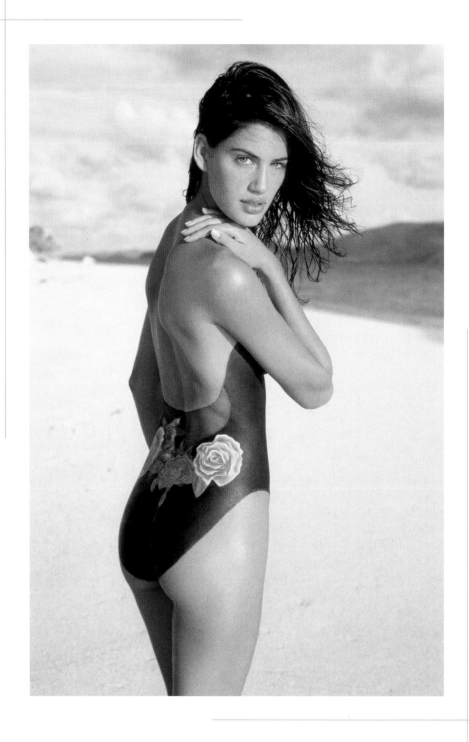

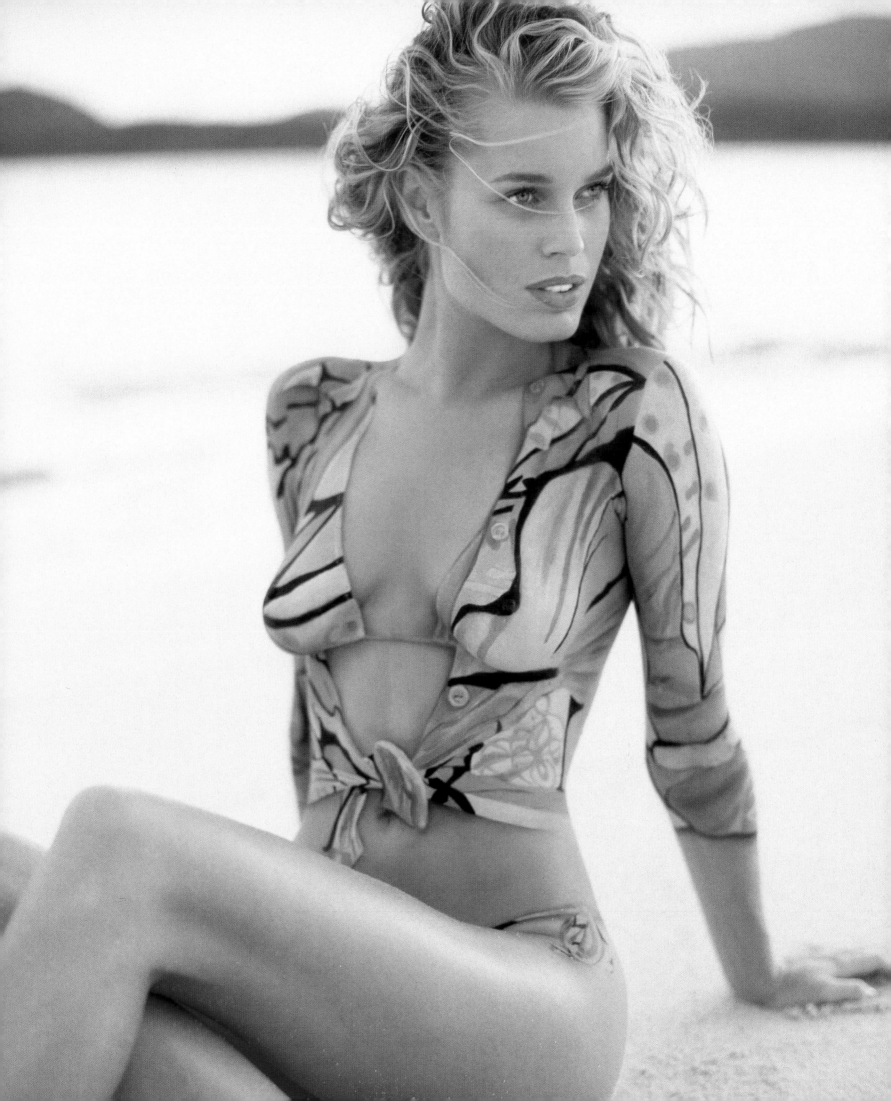

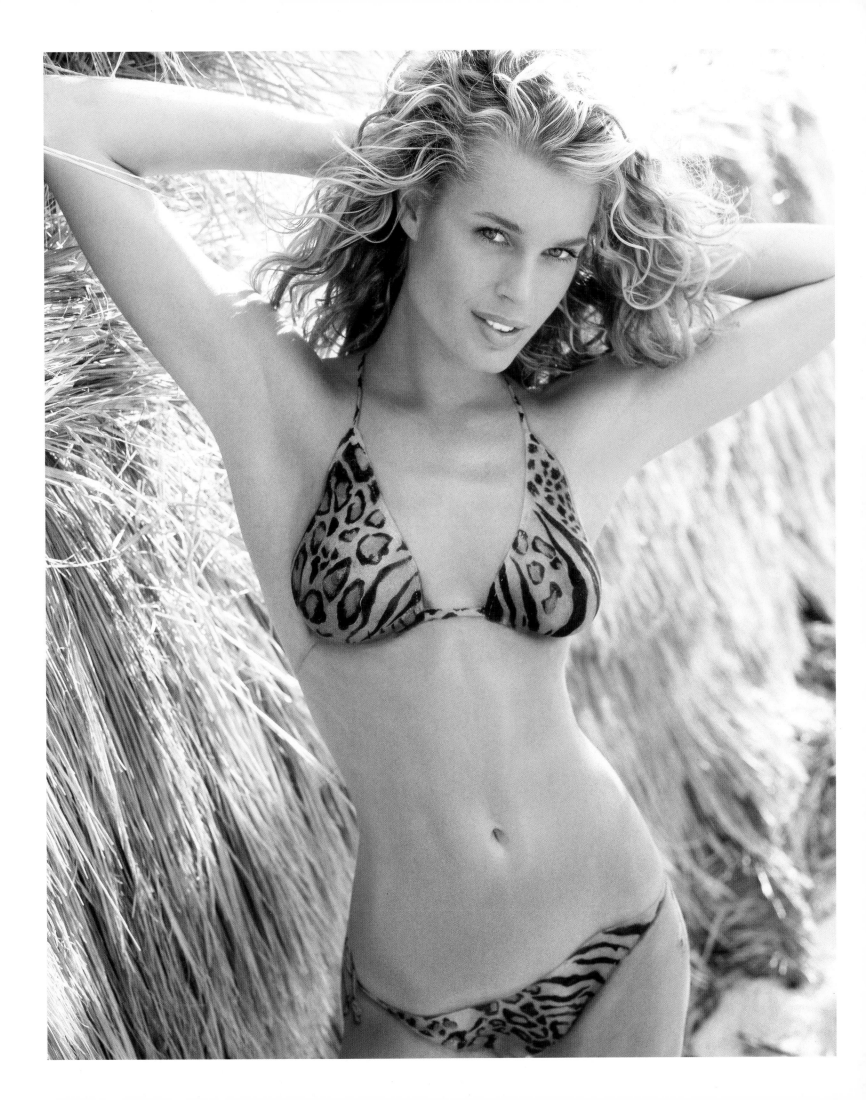

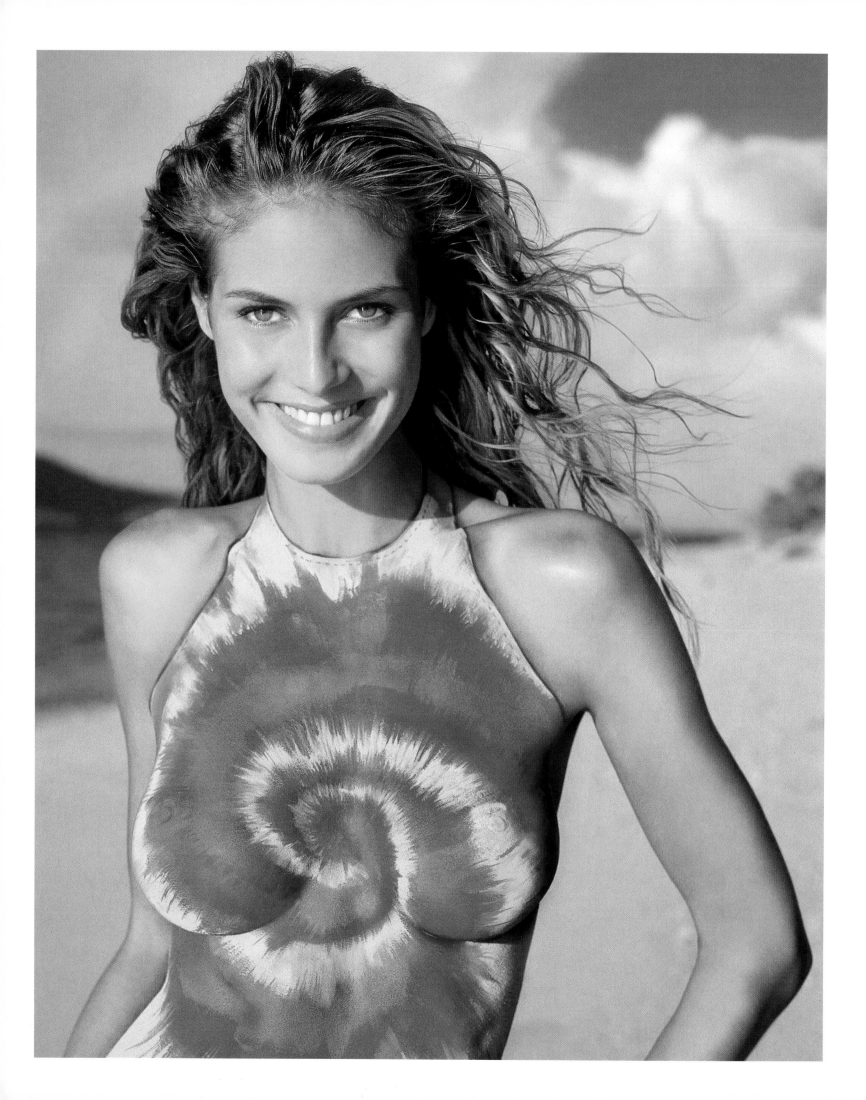

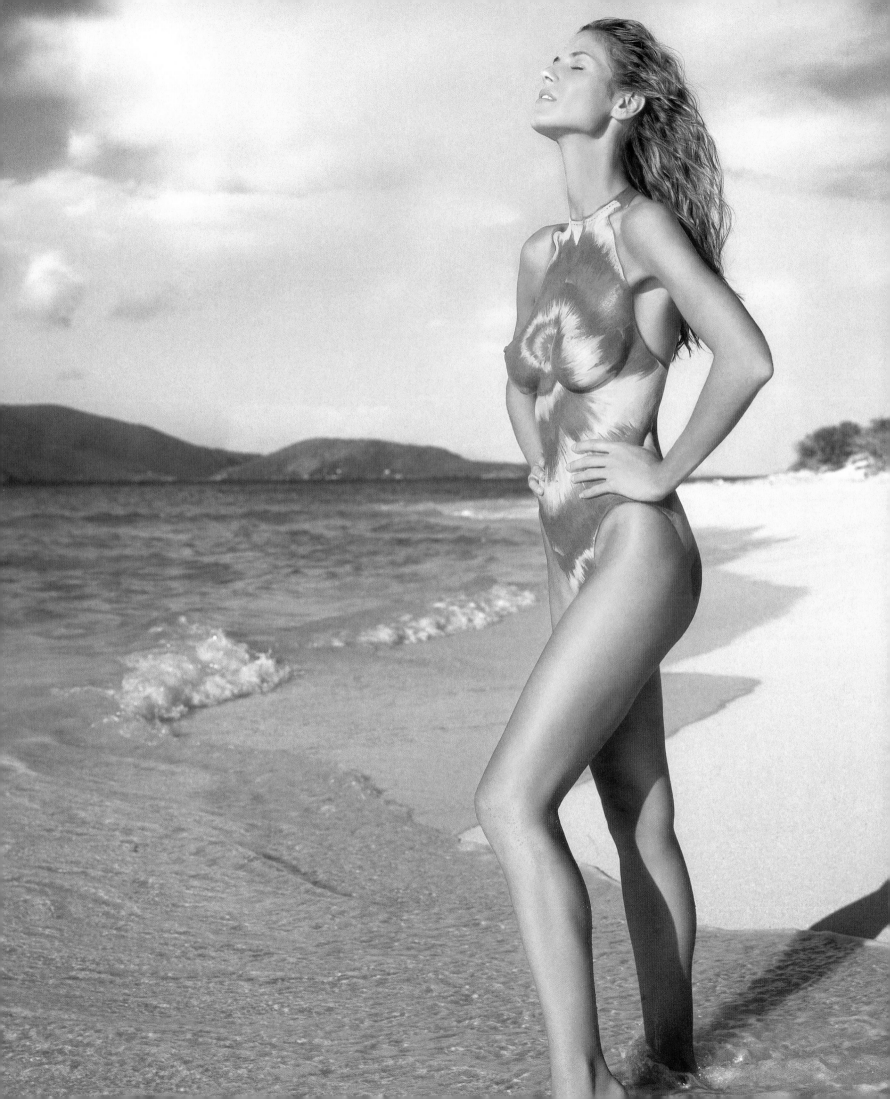

"Skin is your canvas. You have to prime it and enhance it to make it the most luscious. And then it's a natural transition to photography, to lighting the body and coloring the *moment*."

~ *Joanne Gair*

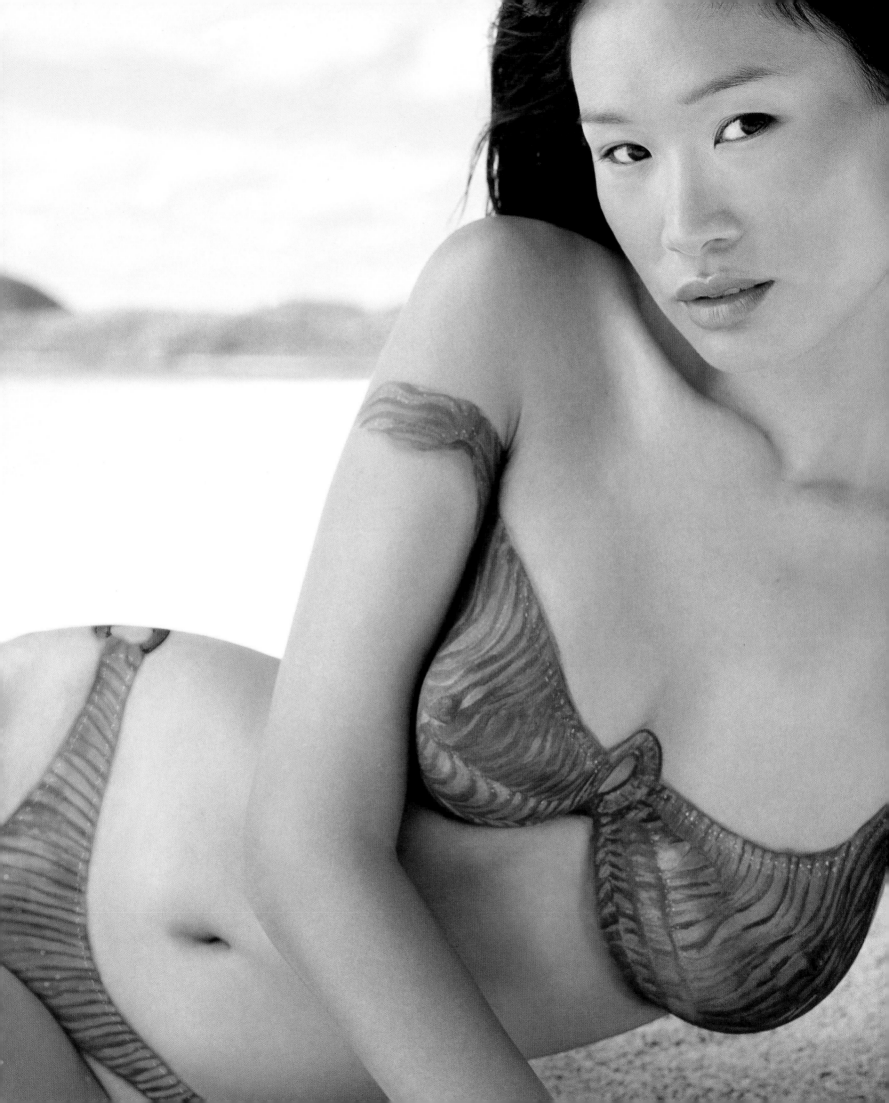

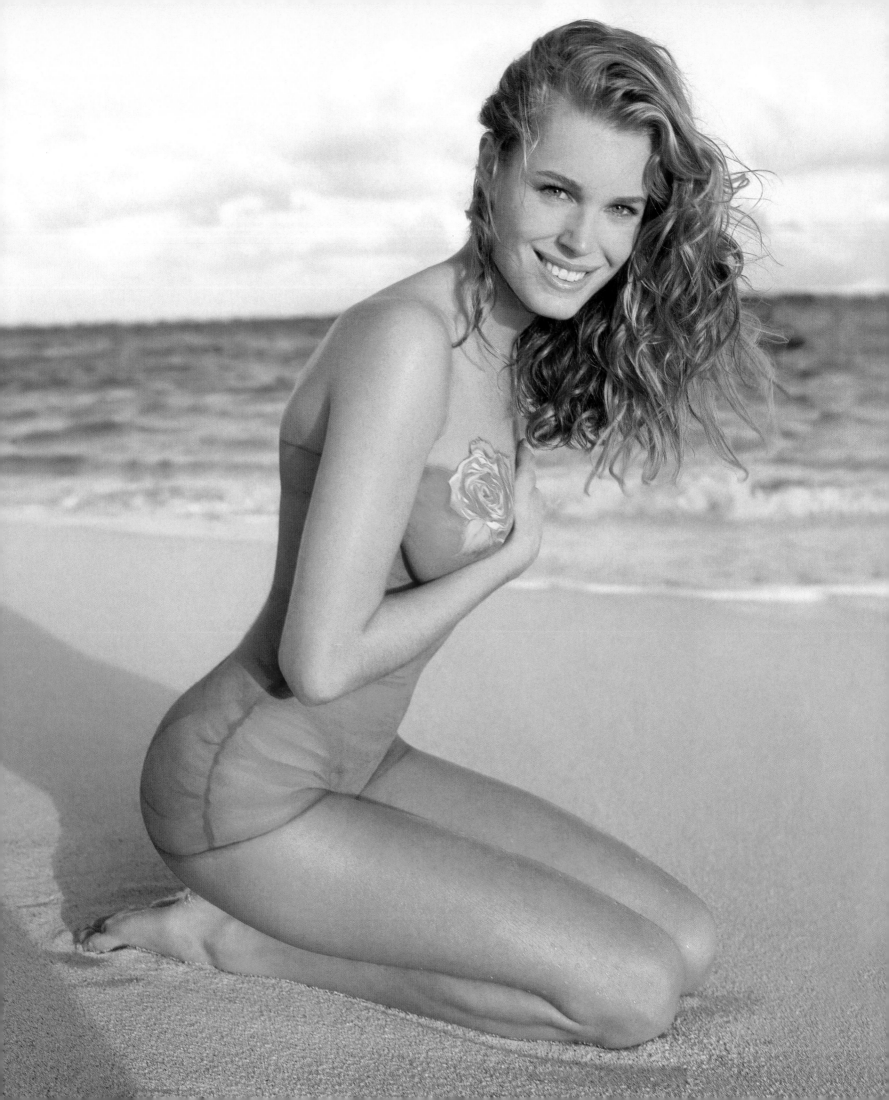

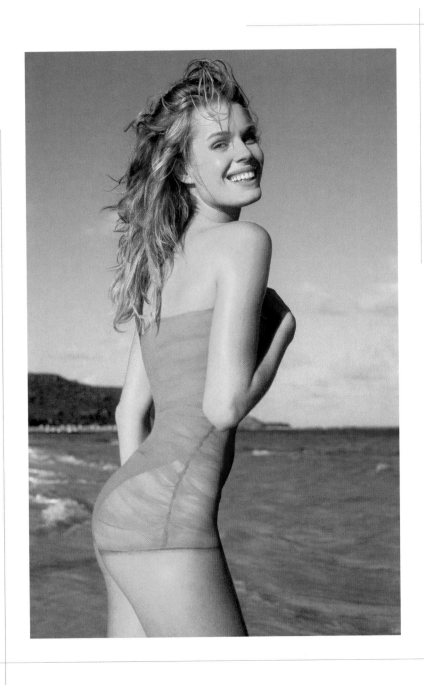

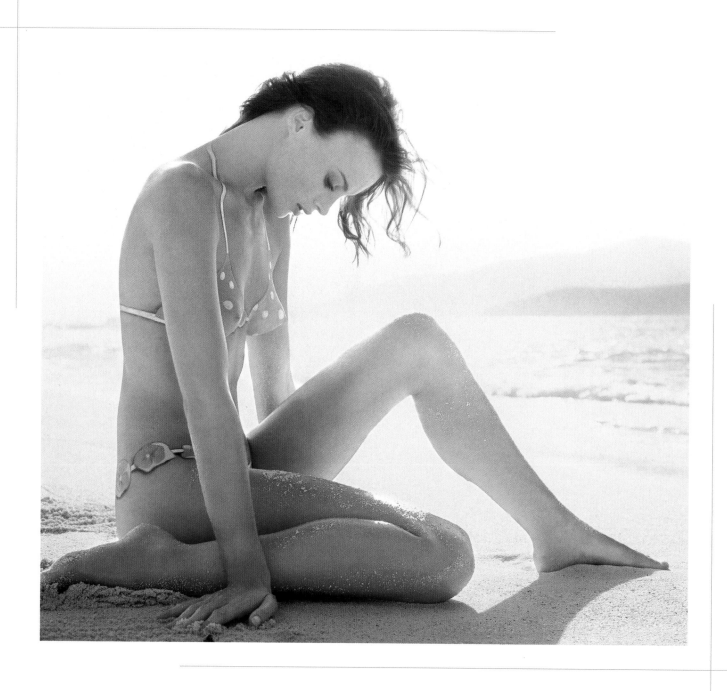

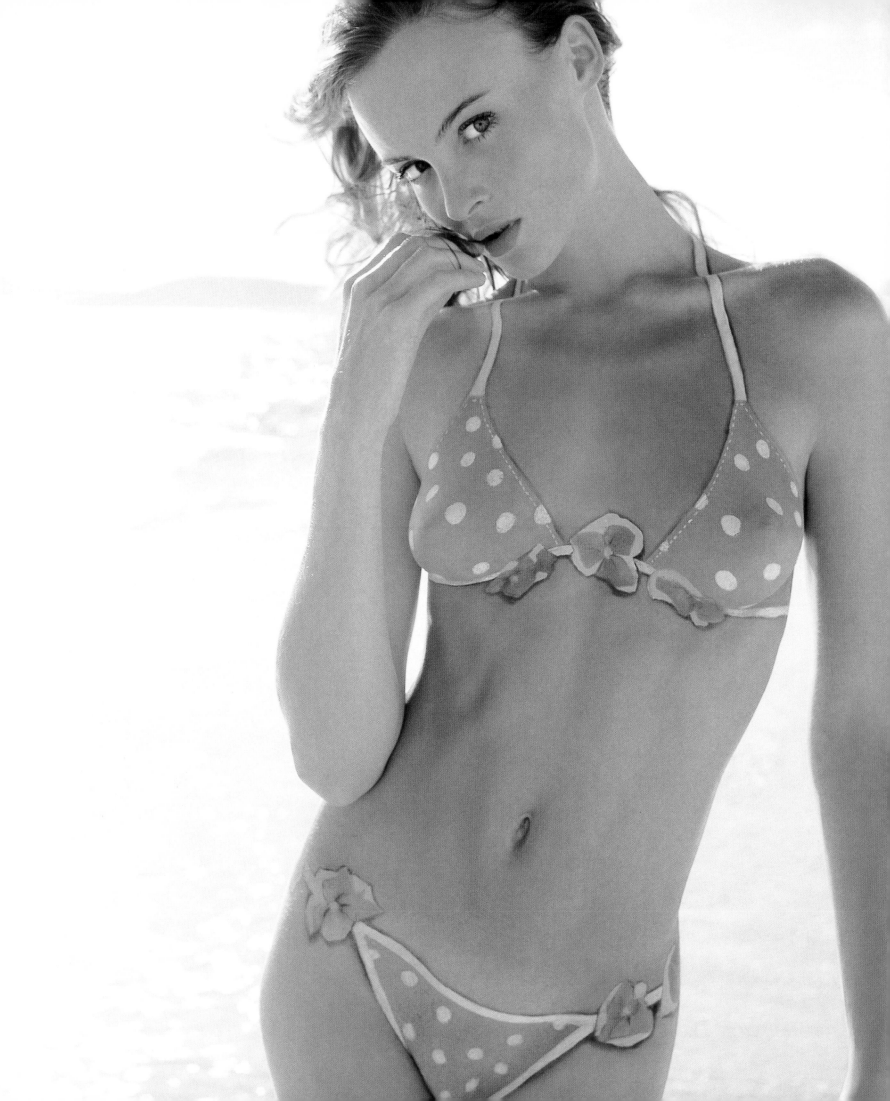

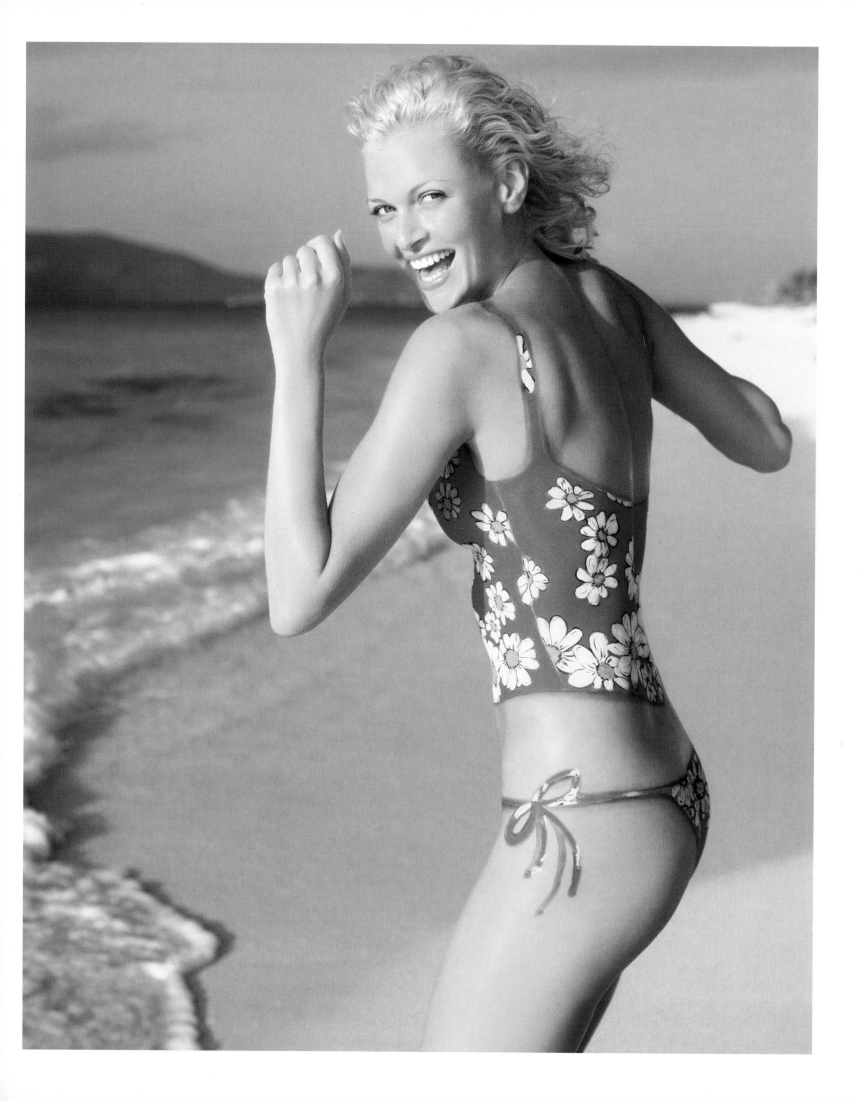

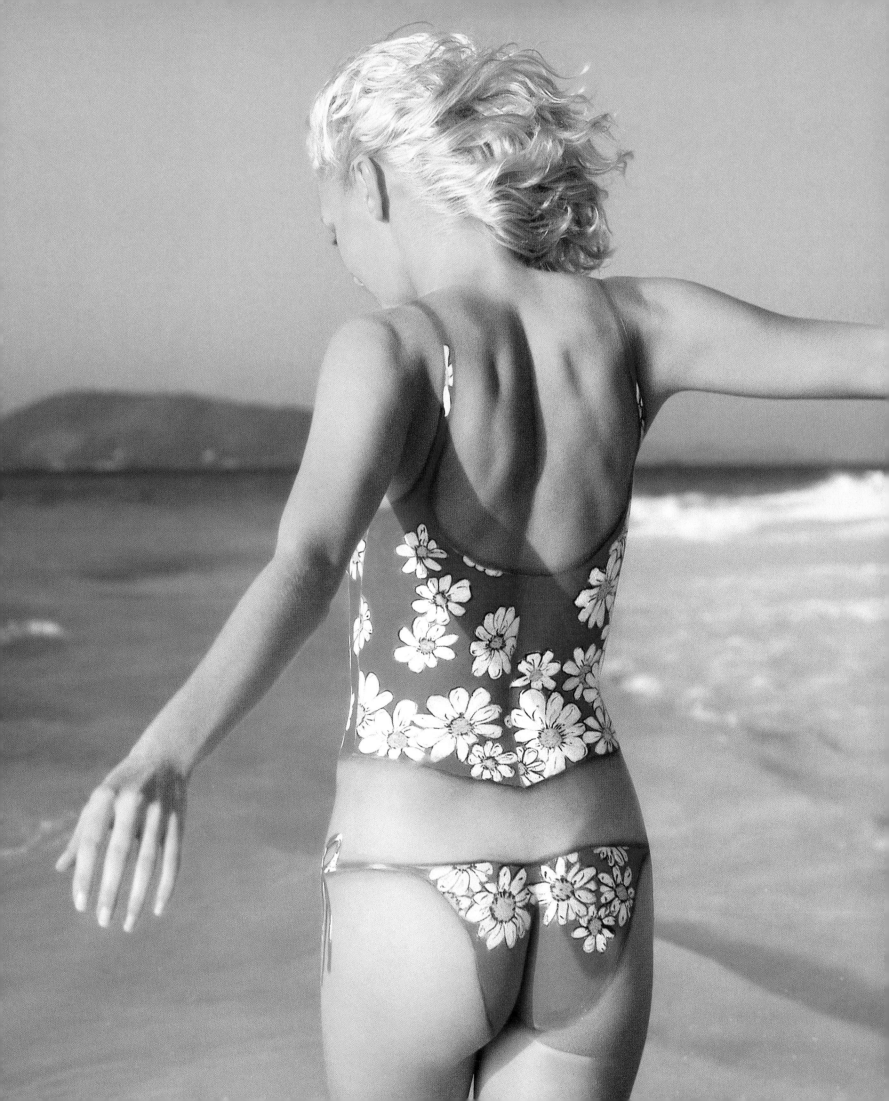

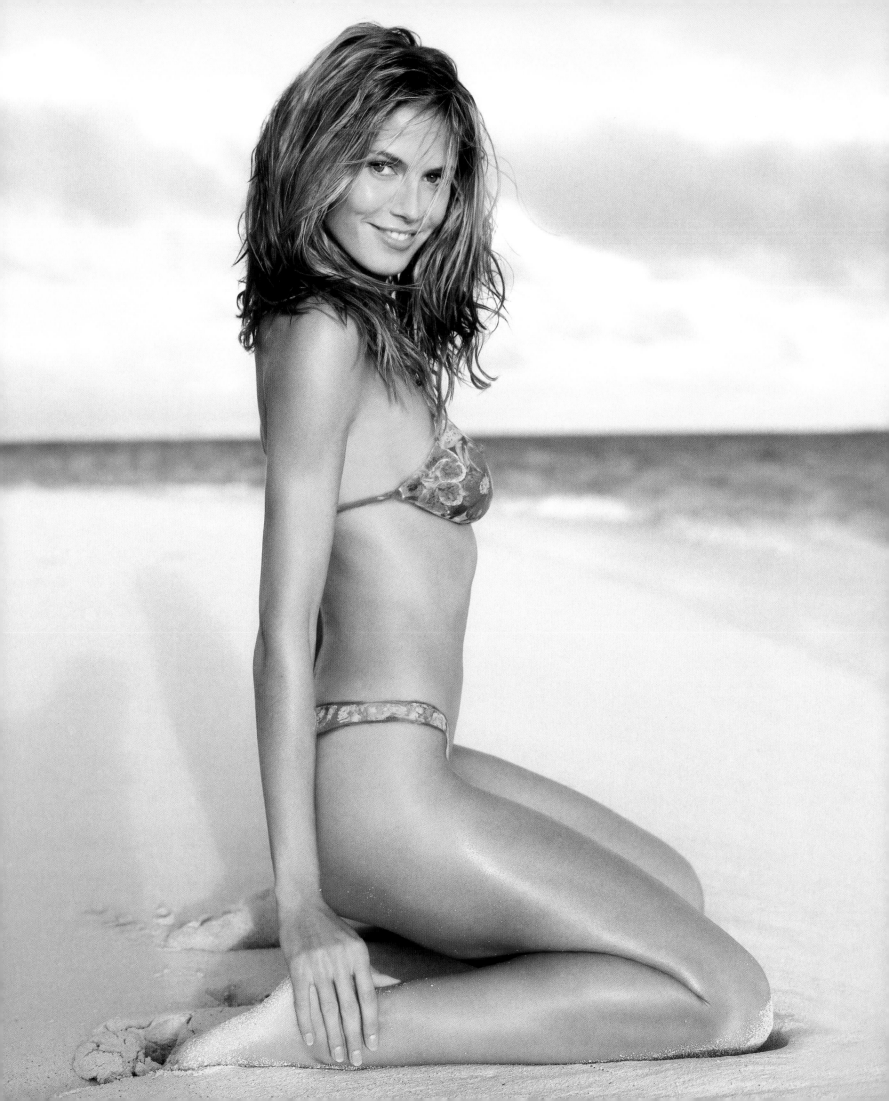

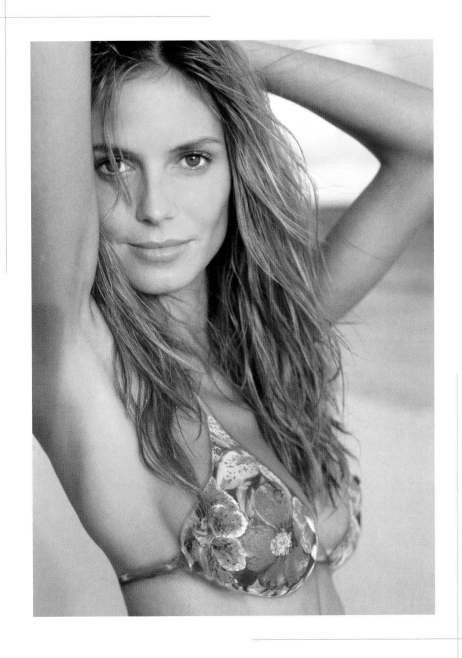

"The coolest part is when you actually *see* the painting for the first time, on your skin. When the whole thing was ready, it was amazing. I was like, 'Wow, those flowers are *real*.' "

~ *Yamila Diaz*

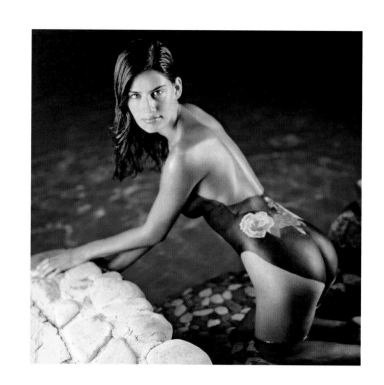

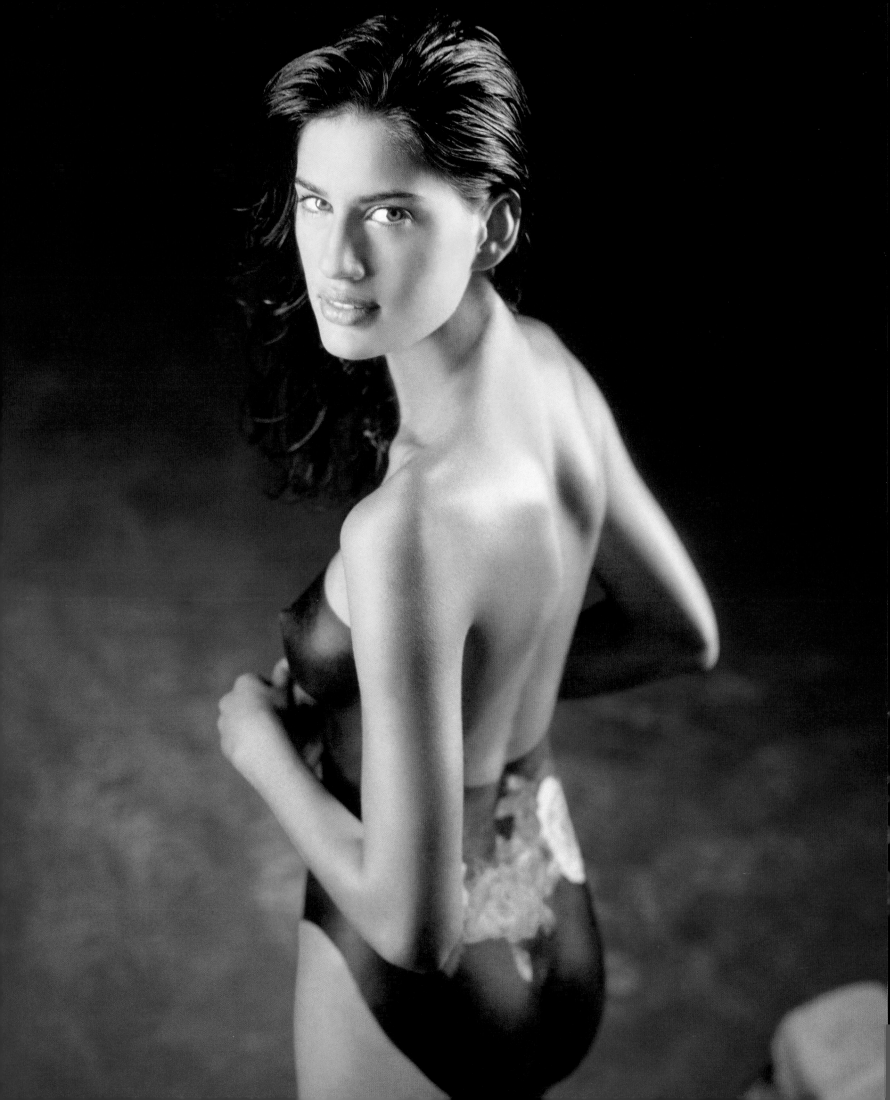

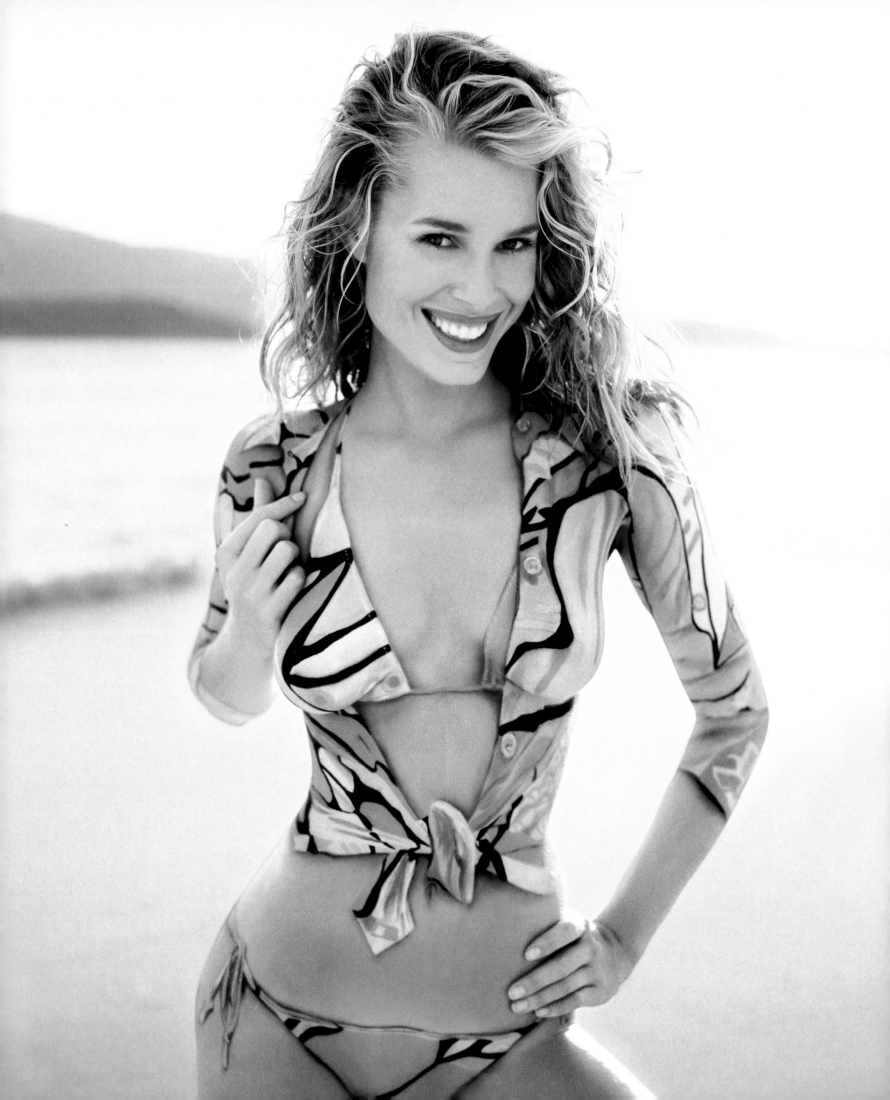

"We don't want to be predictable. It's all about creating enthusiasm and coming up with something new every time."

~ Joanne Gair

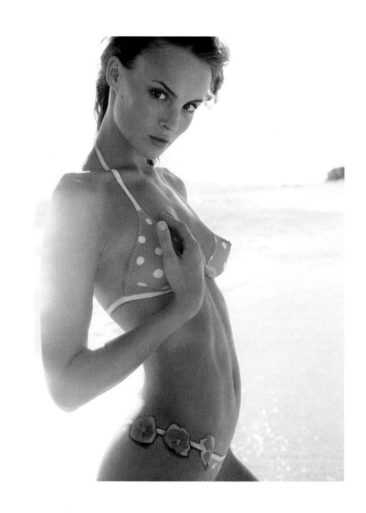

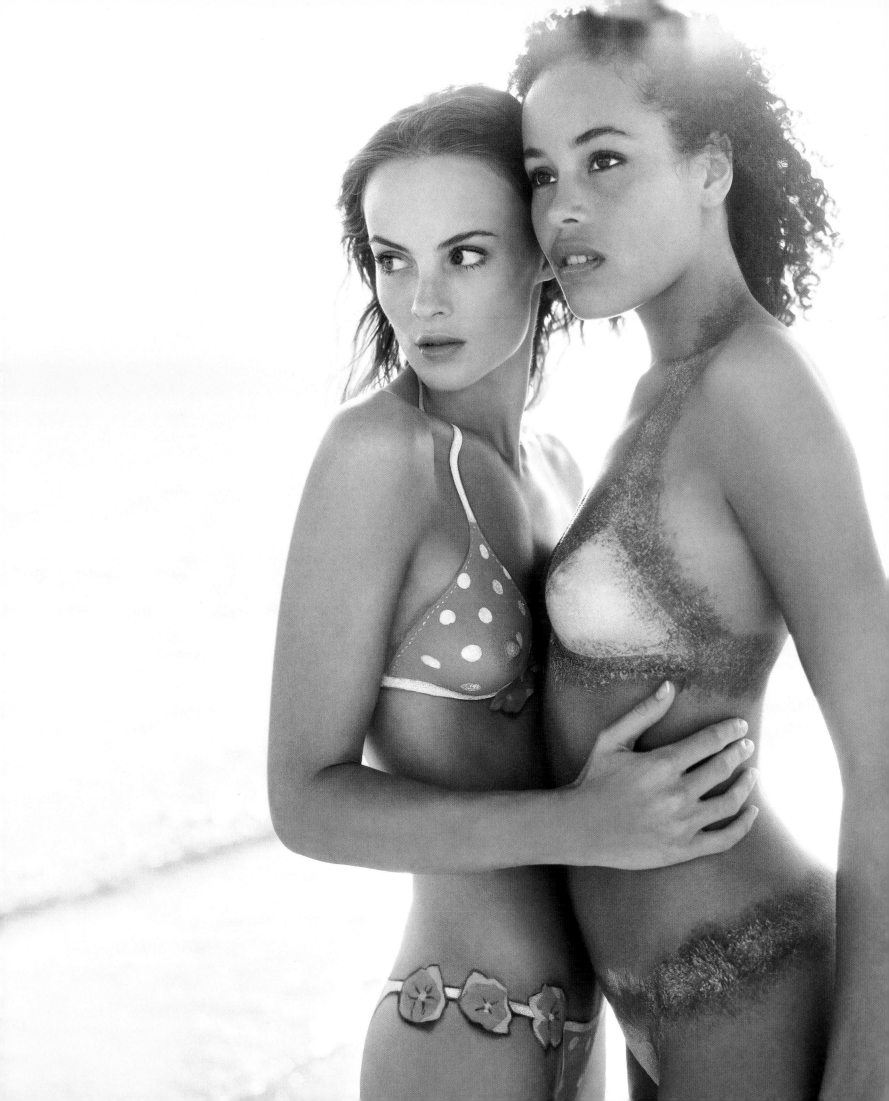

"I was very excited to be painted by Joanne—she had done Demi Moore, Elle Macpherson, all the stars, basically. I was just at the beginning of my career, so for me it was like, 'Wow, this is an amazing woman, doing this amazing art.'"

~ Heidi Klum

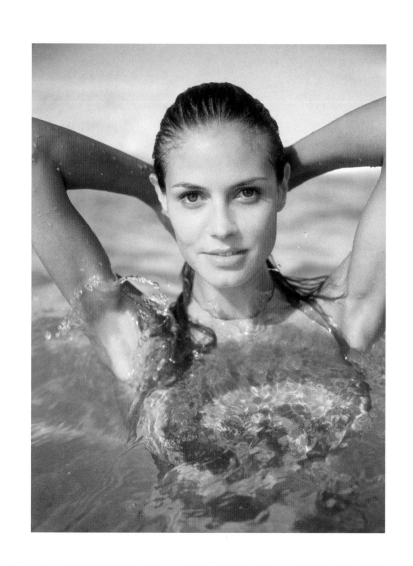

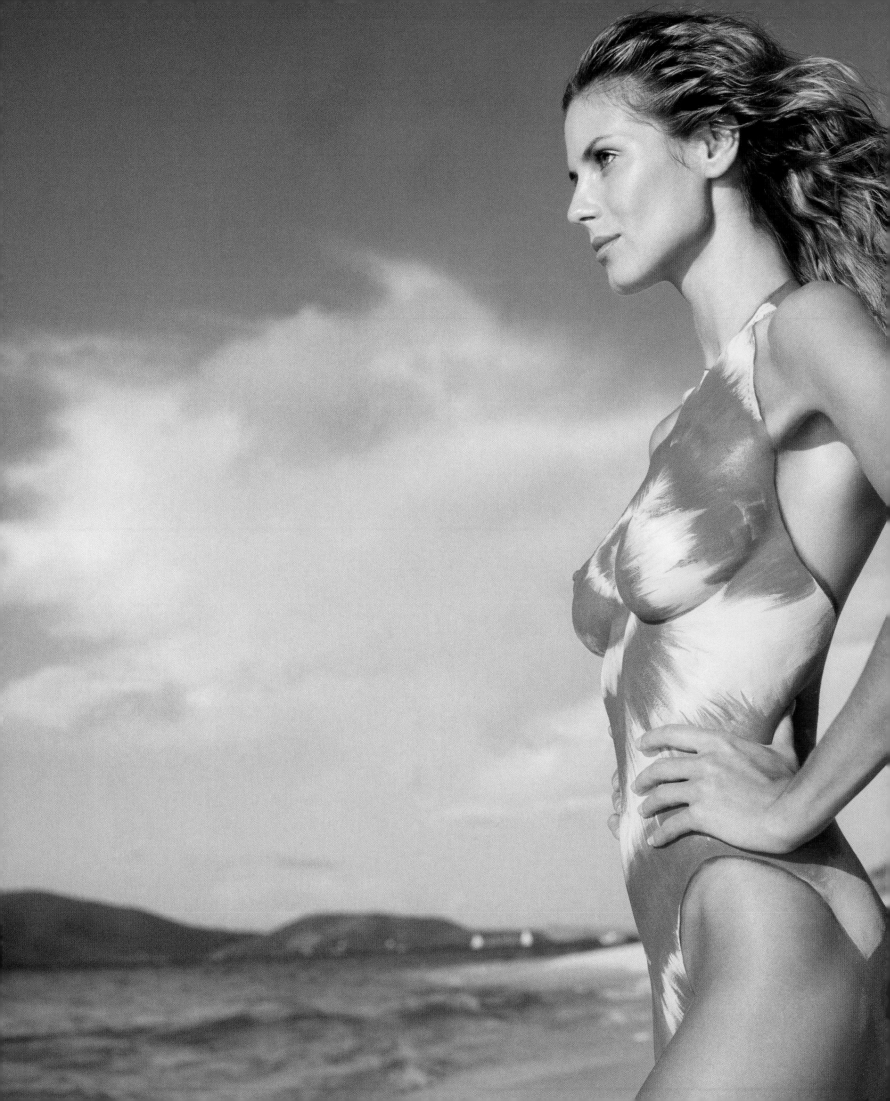

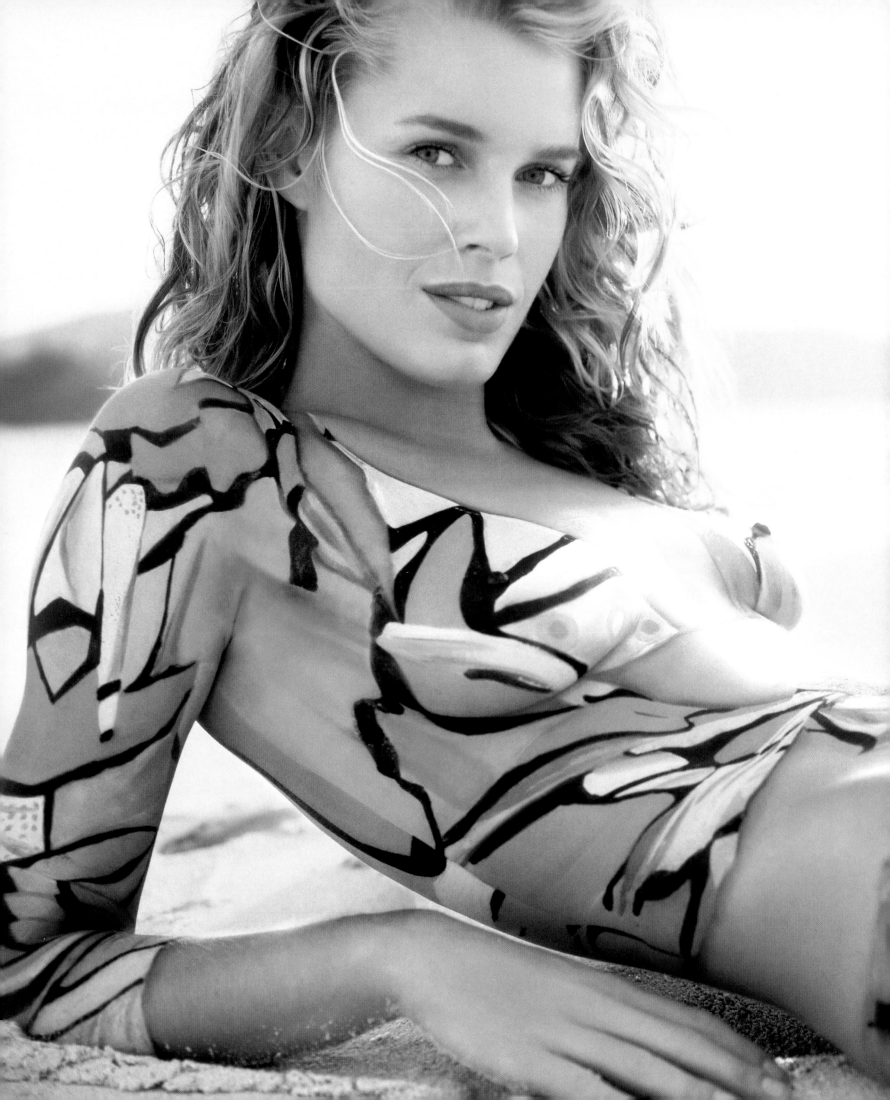

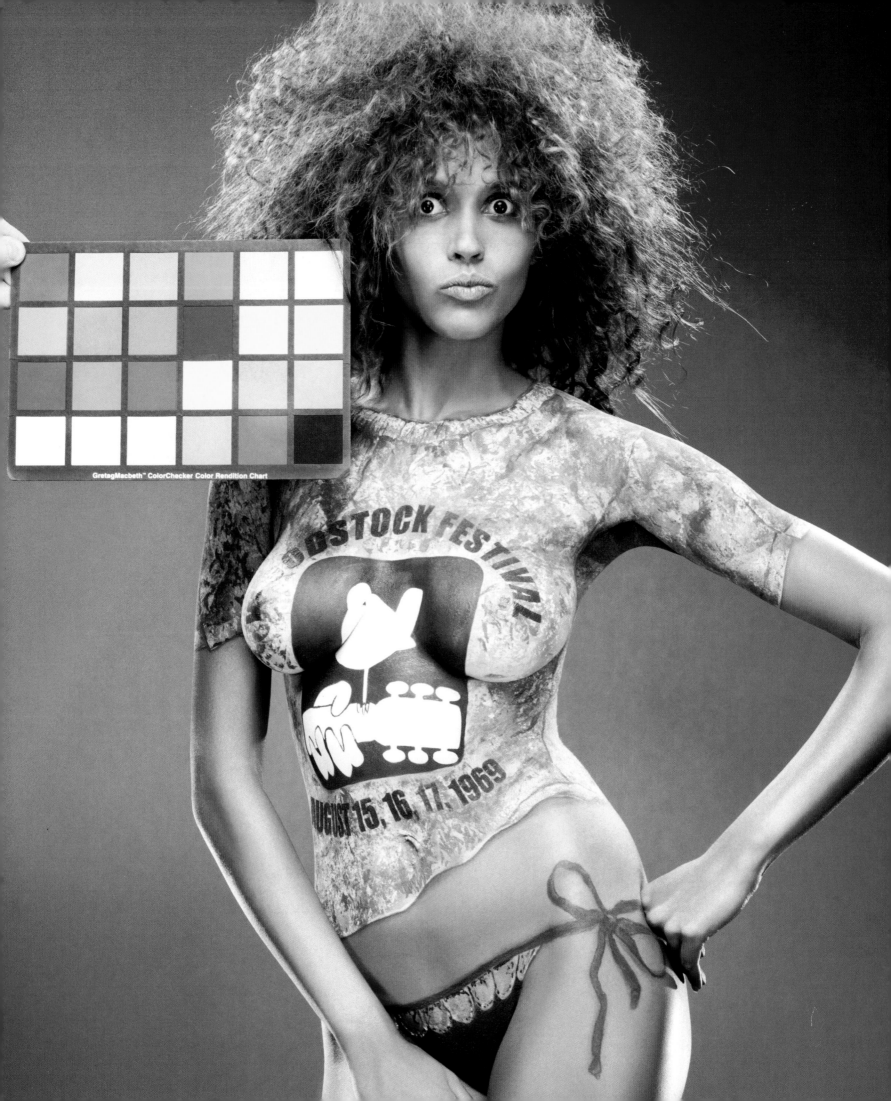

T

Fit to A TEE

Photographs by
JOANNE GAIR

The assignment:
Pay tribute to
rock's rollicking
past with
body paintings
of vintage
concert T-shirts.
The result:
electric ladyland

"I've had four painted suits in three SI shoots. I think this is my favorite, though, because I'm such a rock and roll girl, and I'm glad I got to do the Stones."

~ *Marisa Miller*

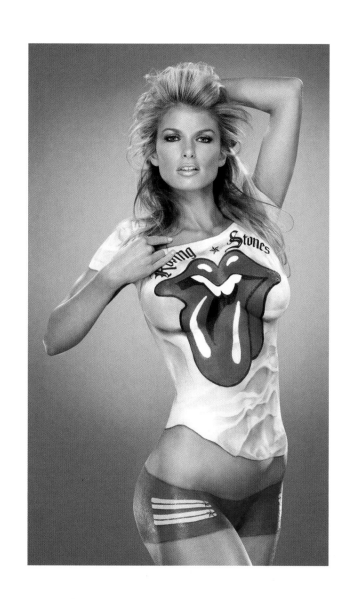

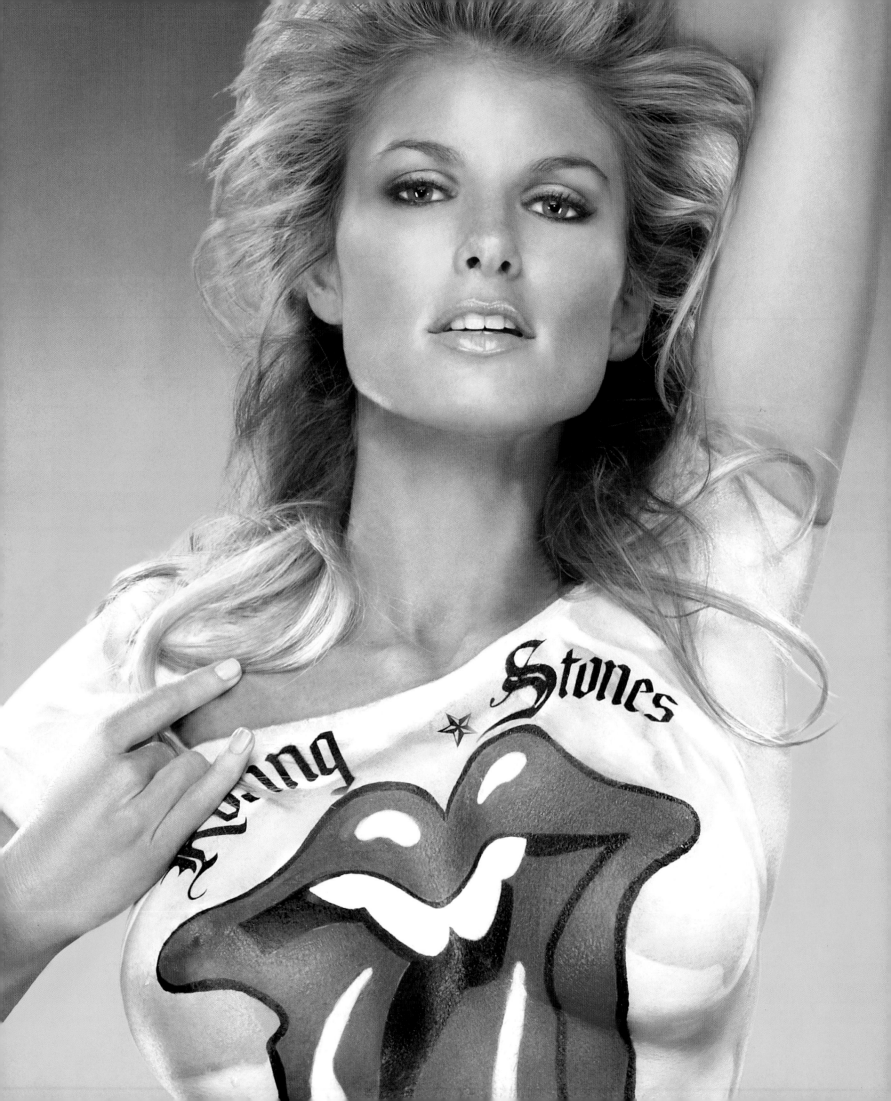

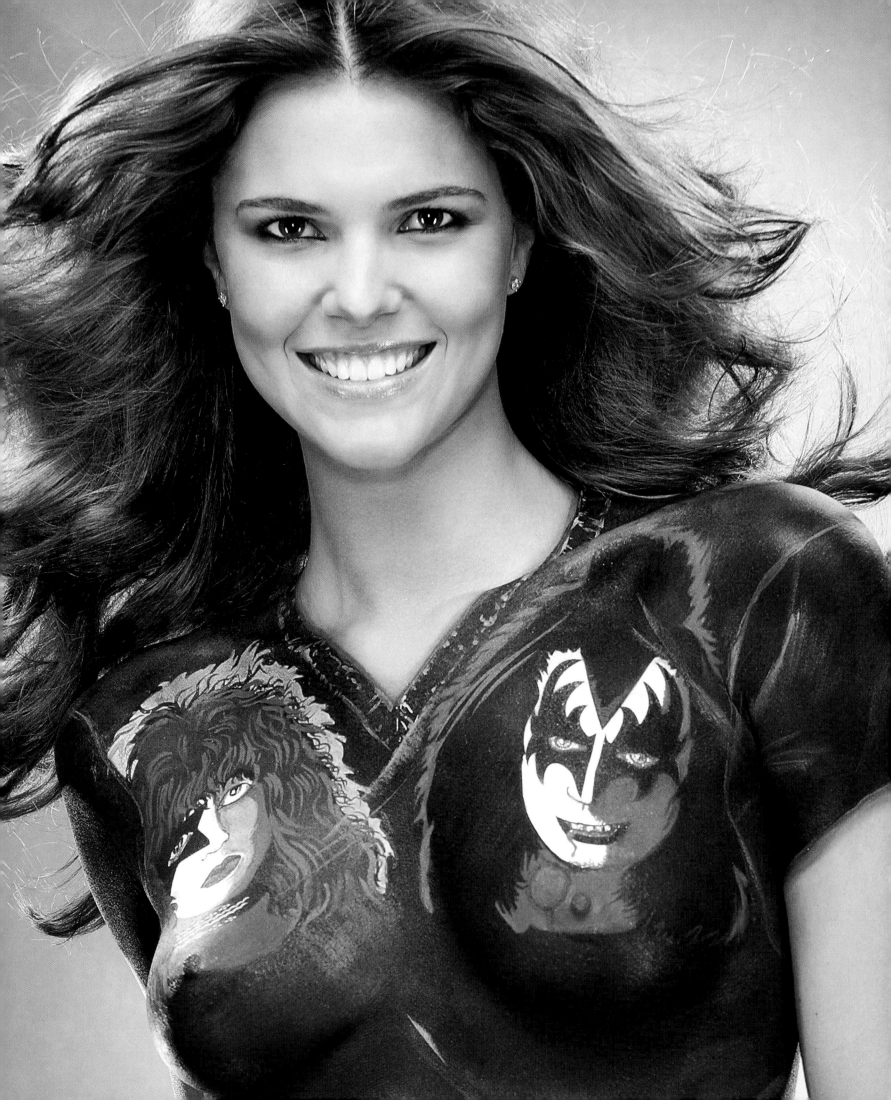

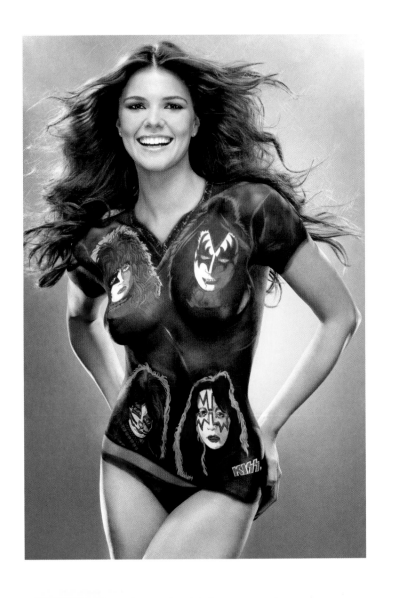

"For the *KISS* shirt I needed a strong body, with shoulders and hips that would hold four symmetrical faces. Daniella has a very sporty body, so she was chosen for that."

~ *Joanne Gair*

"It actually does feel like I'm wearing a shirt. I've never felt so comfortable naked in front of so many people in my life! So, you're naked but clothed in a strange way."

~ *Tori Praver*

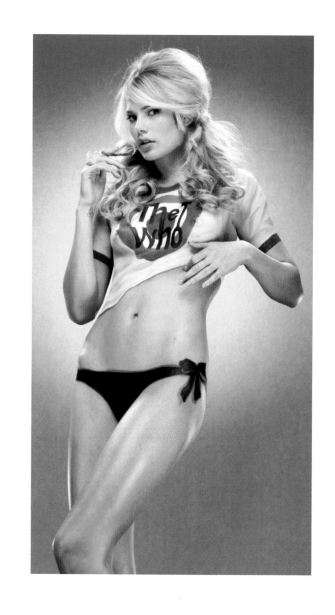

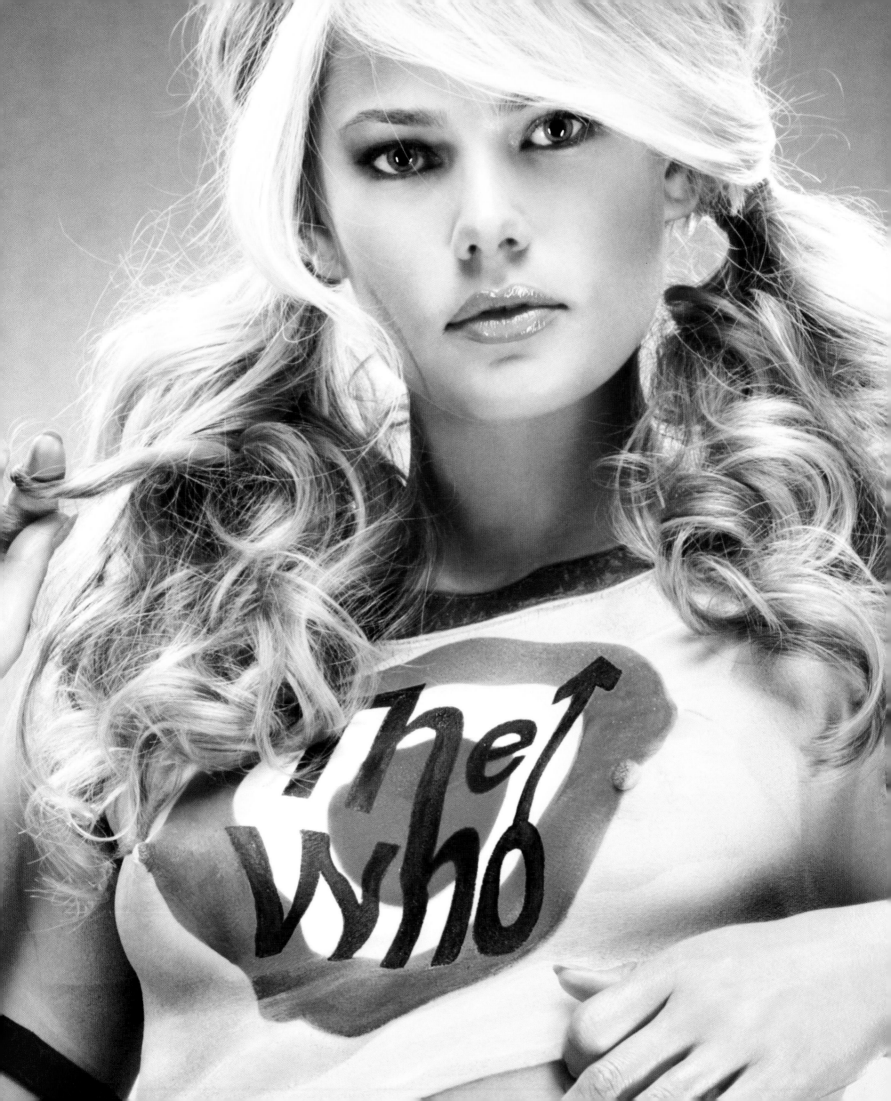

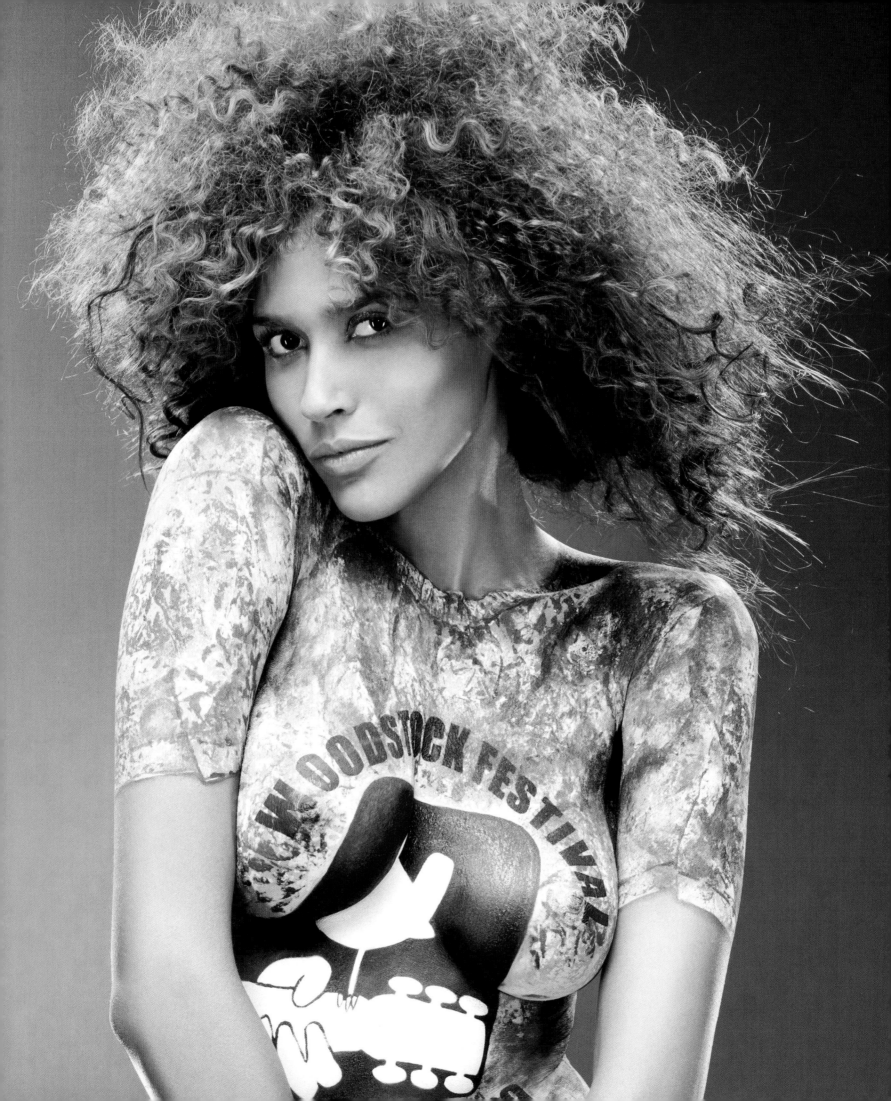

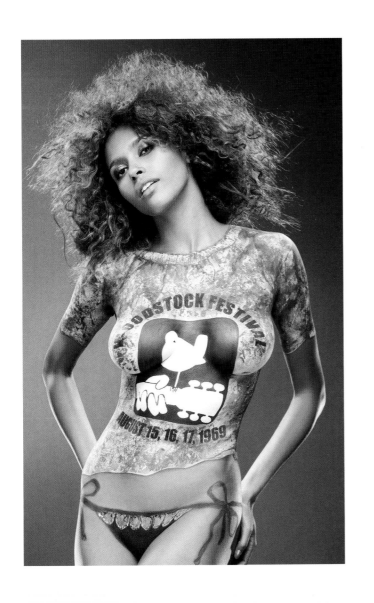

"Ana Paula has gorgeous skin. When you look at her, I mean, what a gem! Nothing in the painting has cracked, nothing has moved. Now *that's* a perfect canvas."

~ Joanne Gair

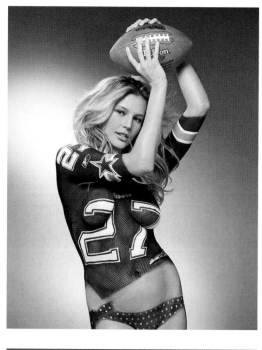
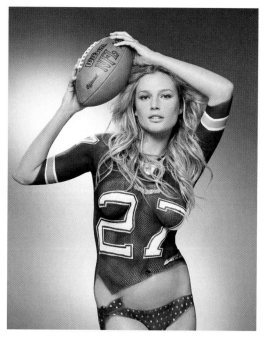
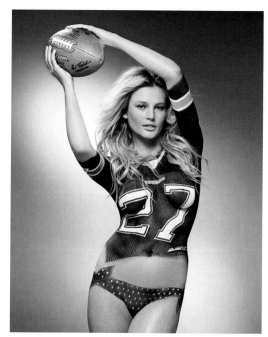
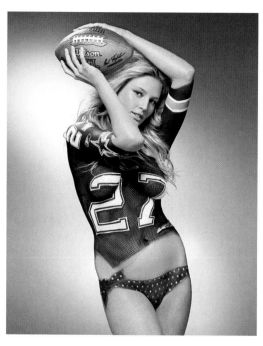
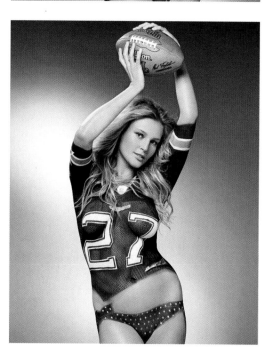
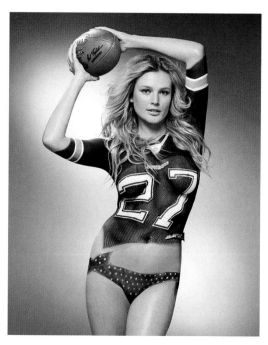
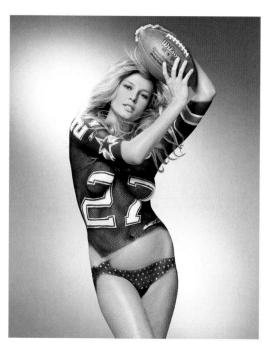
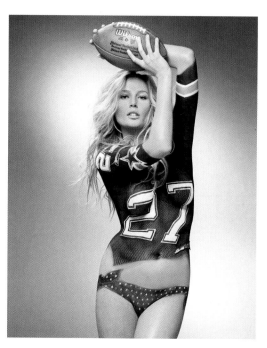
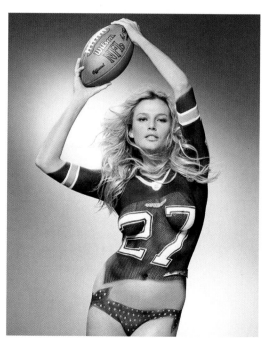

S

Uniform APPEAL

Photographs by
JOANNE GAIR

Suiting up

for your
favorite team
is a much
more attractive
proposition
when you
replace those
old double-
knits with
a few coats
of paint

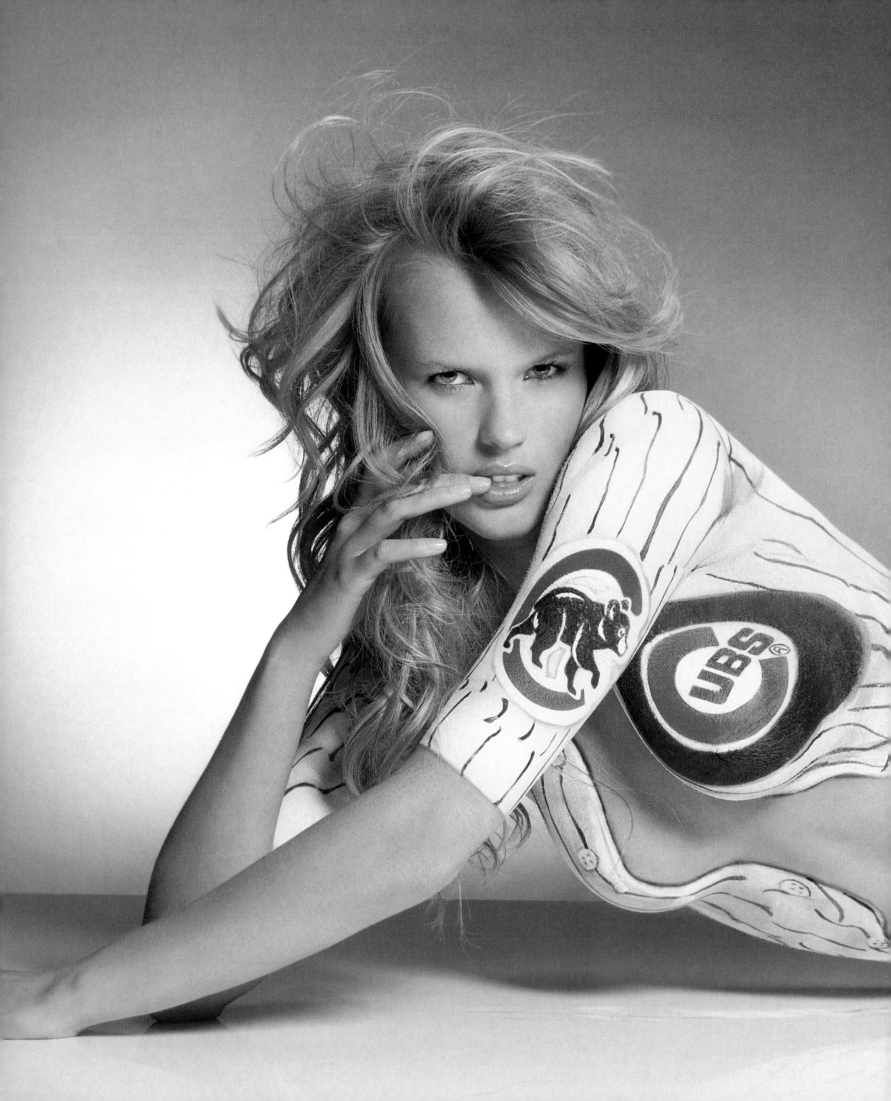

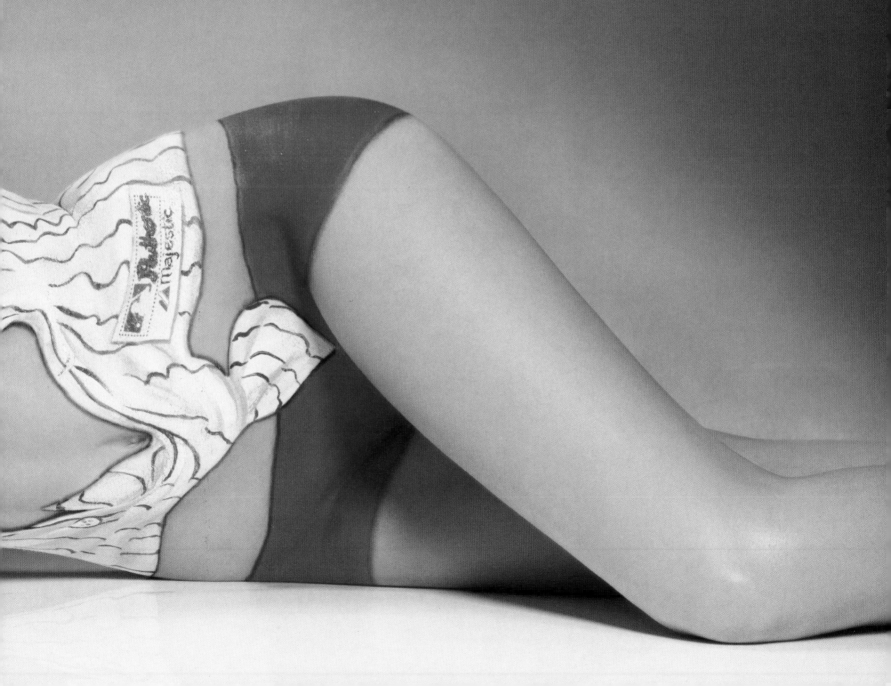

"Lettering is hard to paint: You're trying to make it linear and correctly spaced, but the body form distorts it."

~ Joanne Gair

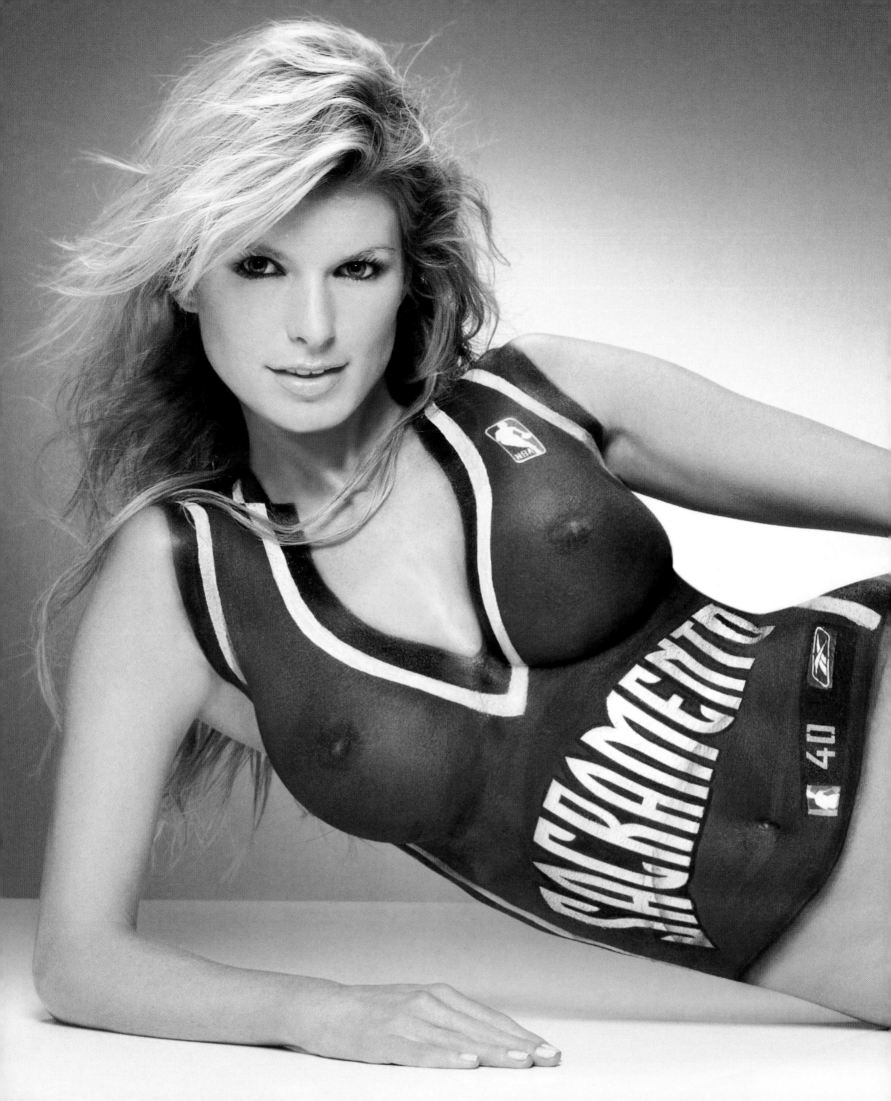

"You're naked, but you don't *feel* naked. When you're moving around, bouncing everywhere, that's when you're like, oh, I don't have any clothes on."

~ Marisa Miller

"The secret to my body painting, of course, is to make it dimensional. It's about going back and forth, creating highs and lows with color."

~ Joanne Gair

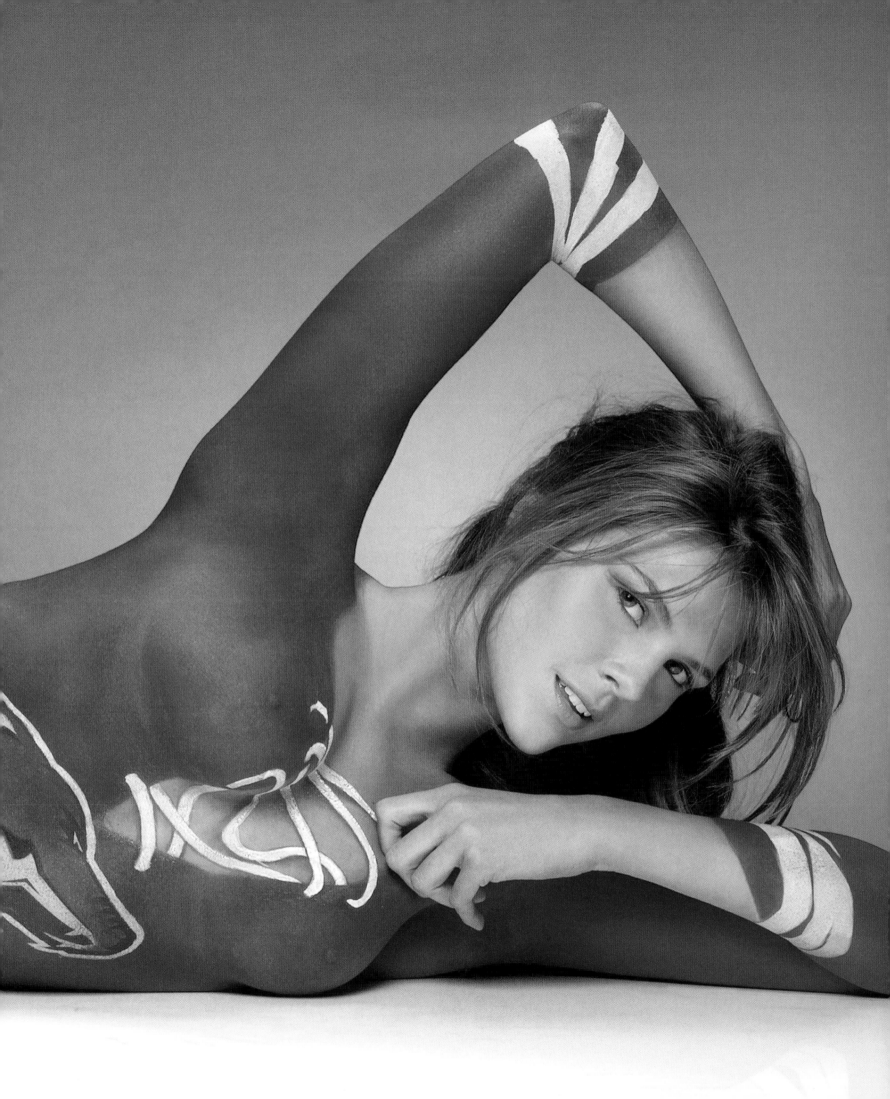

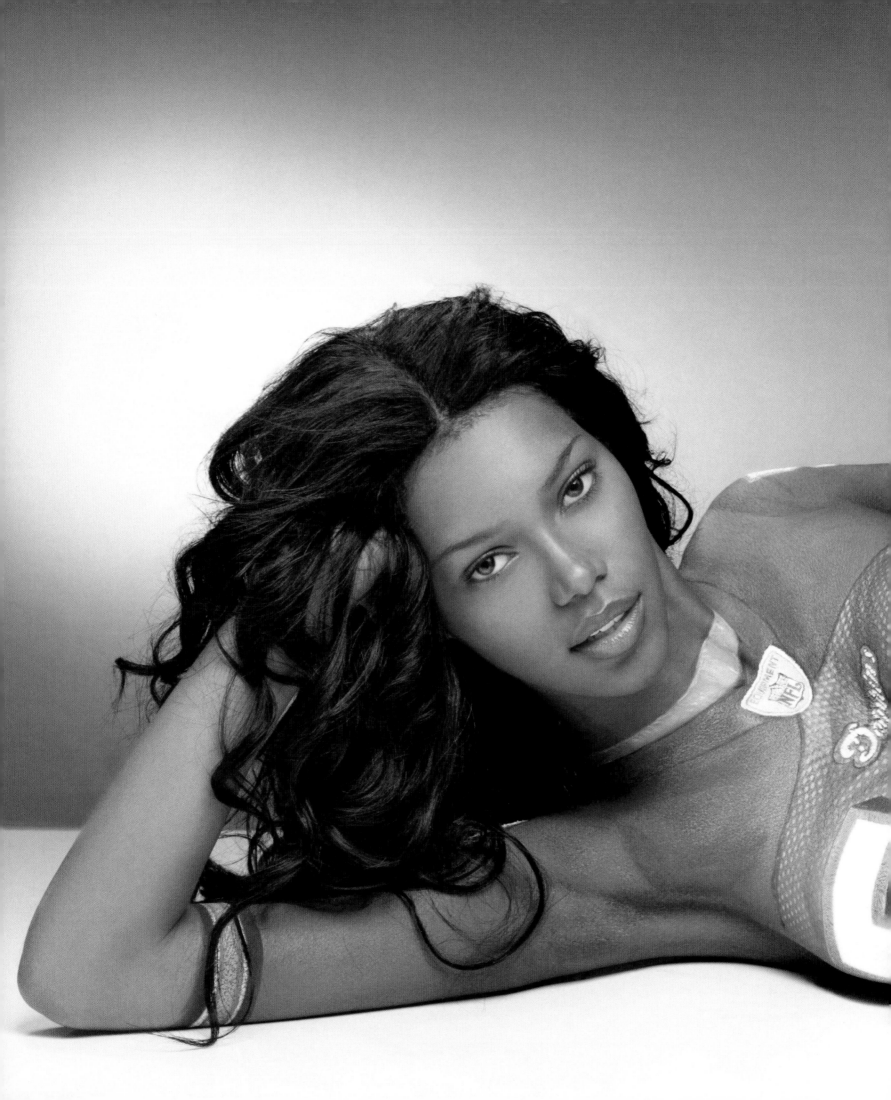

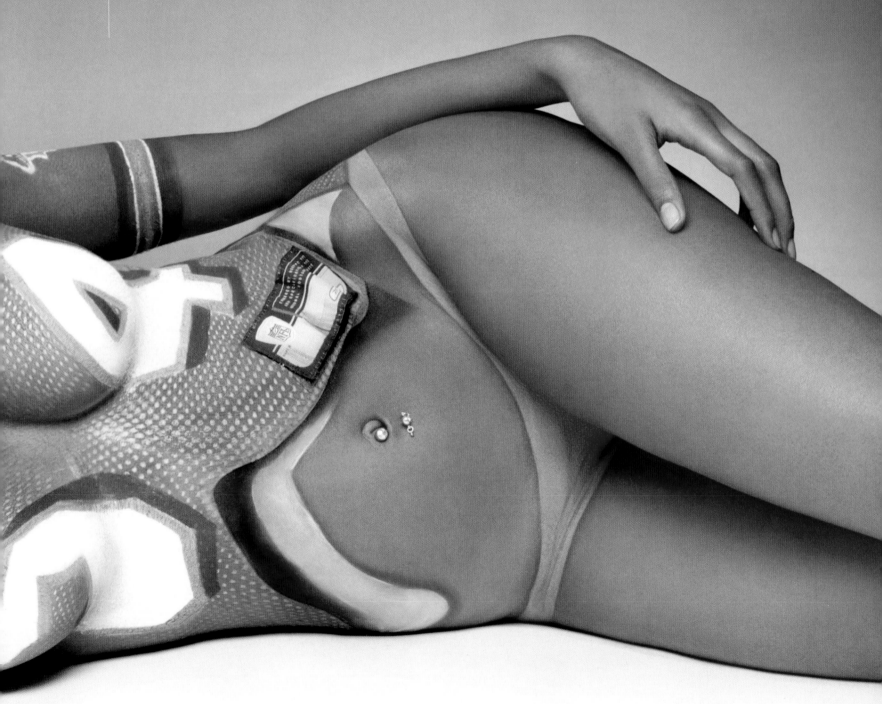

"Working on numbers with big-busted girls has its own challenges. Stenciling won't work on a curved surface. I know that better than anyone."

~ Joanne Gair

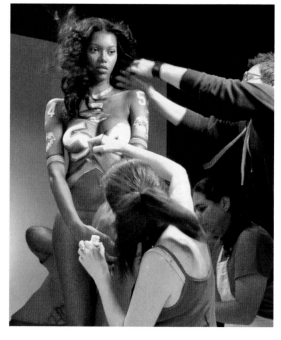
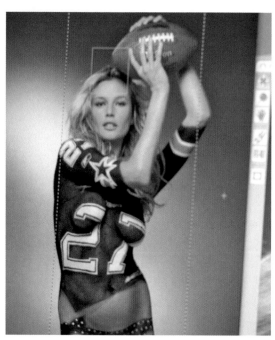

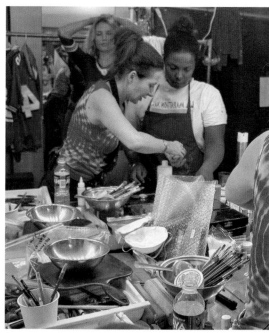
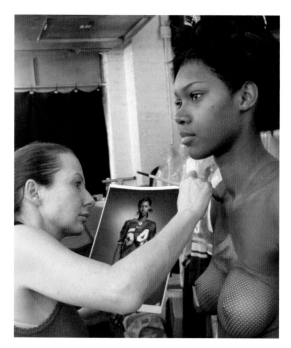
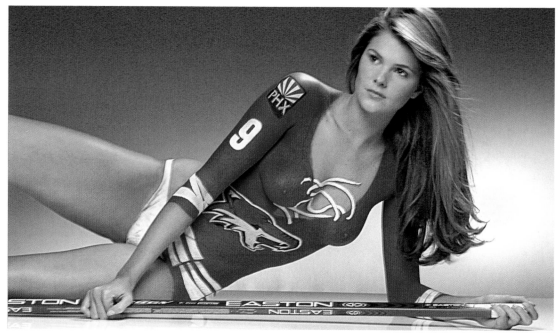

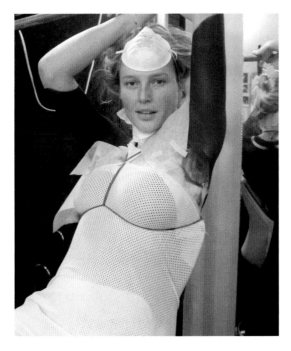

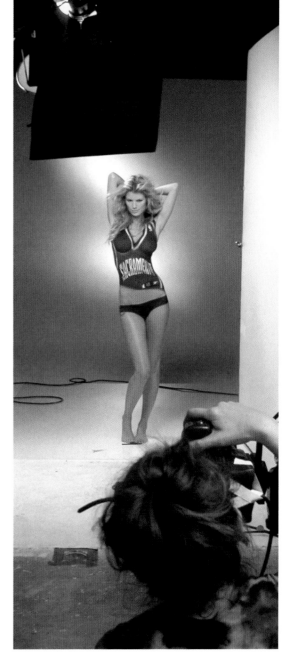
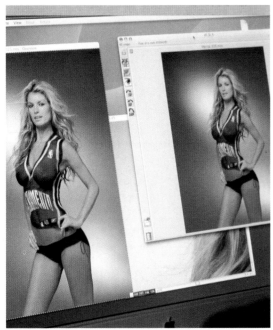
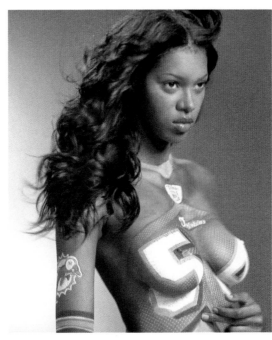
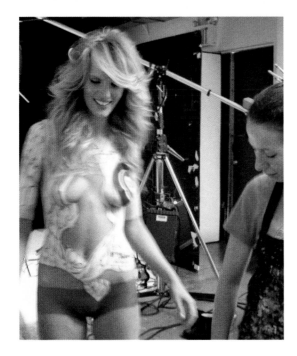
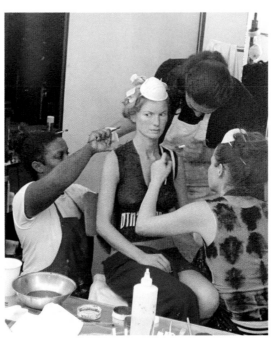

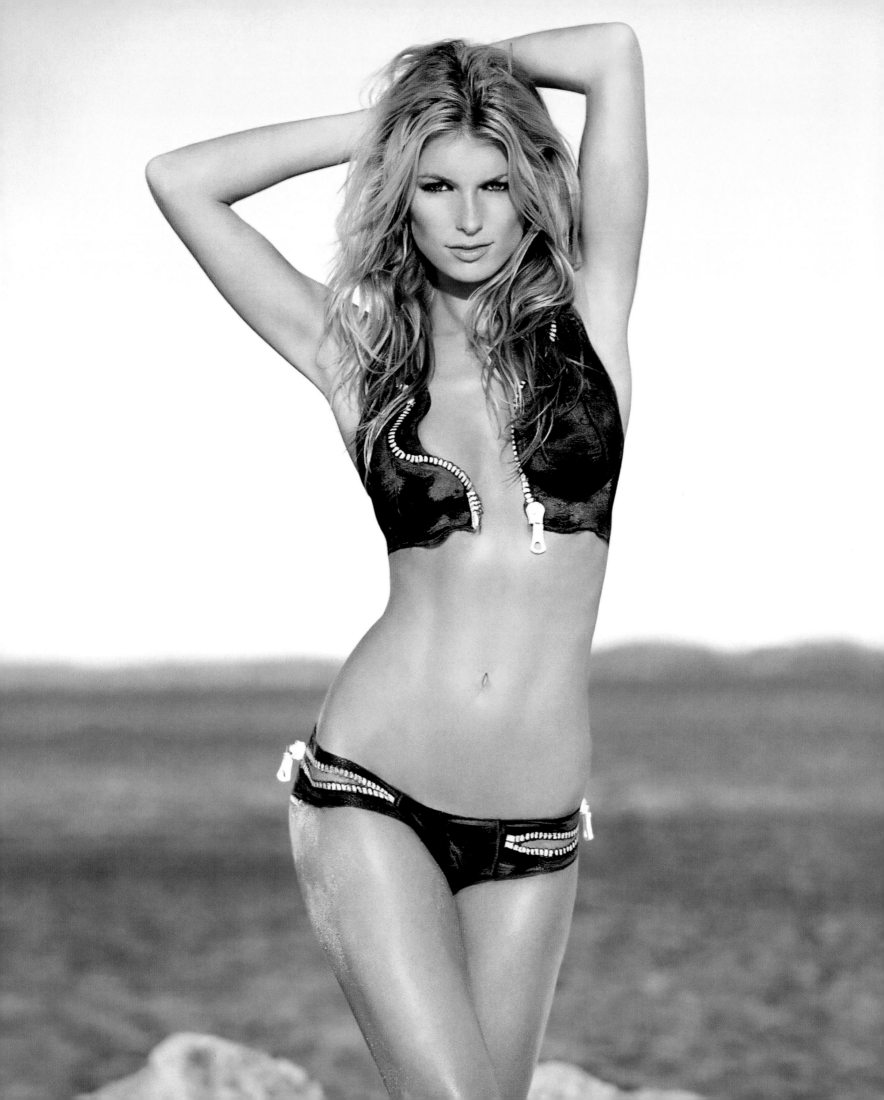

A *Very* THIN COAT

Photographs by
STEVEN WHITE

In the long history of great art, painters have worked on many surfaces. But what finer canvas than the human body? Especially *these* bodies

"The most surreal thing was stepping outside and feeling like I had a swimsuit on—the complete freedom of having this beautiful design on your body and feeling like you're wearing a suit."

~ *Melissa Keller*

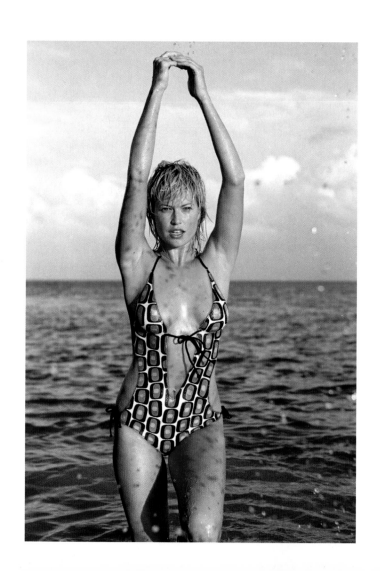

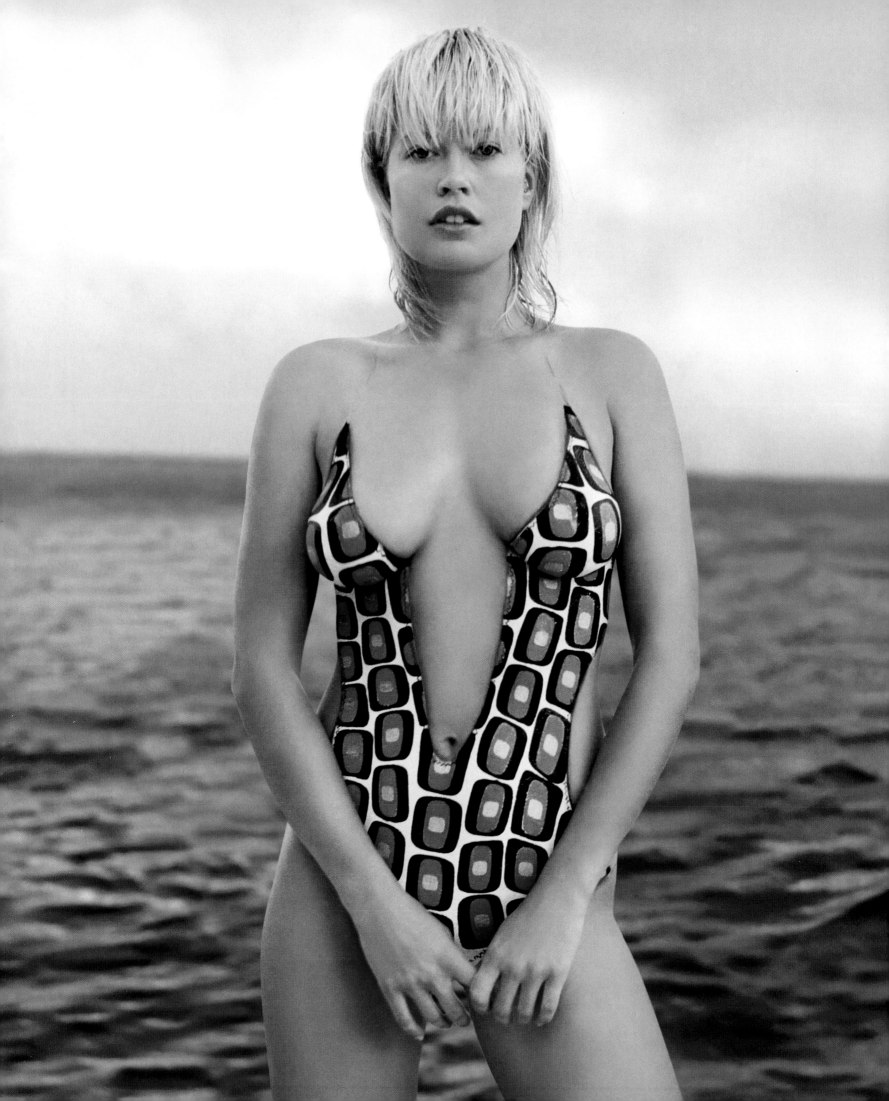

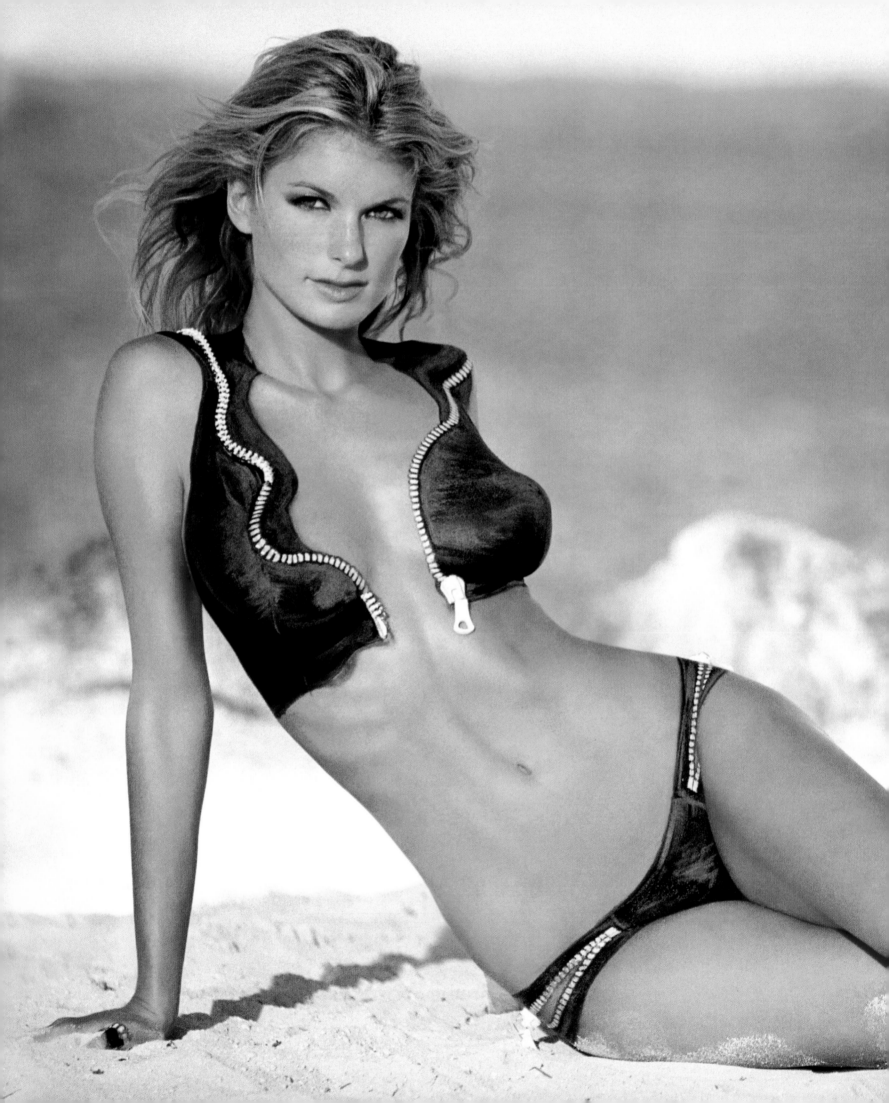

"I just try to hold really still while Joanne works. It's hard—especially when she's painting the ticklish parts."

~ Marisa Miller

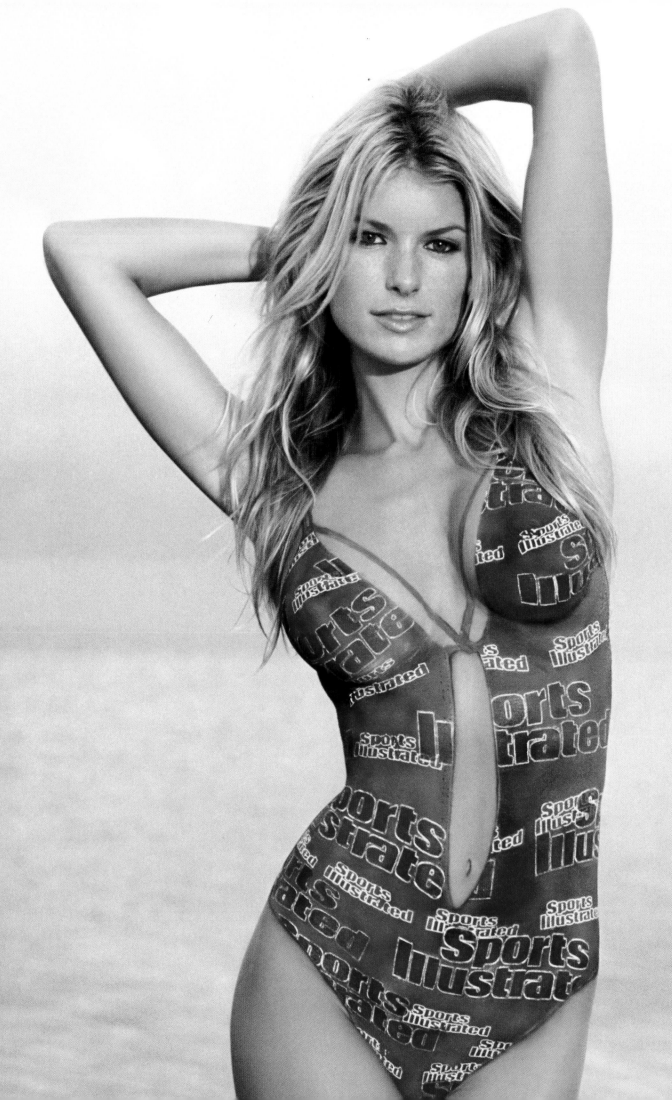

Painter PANTS

A BODY-PAINTING SESSION LEADS
TO ONE SPORTSWRITER'S BRUSH
WITH GREATNESS *By Rick Reilly*

A-Z-BOY ENDURANCE TESTER.
Ferrari reviewer. Stevie Wonder's ironing lady.

Those are some of the sweetest jobs in the world, but they are like being an oil-well-fire capper compared with my job this weekend: painted-on-swimsuit assistant.

Hey, you take the assignments they give you. What are you gonna do, file a grievance?

There are four of us in this villa in the Florida Keys assisting Joanne Gair, who will paint swimsuits on five naked, wriggling canvases. Life is very good.

DAY 1: I am not allowed anywhere near a brush. I am Broom Boy. I am Empty the Empty Trash Can Guy. I try to look busy, whistle a lot and catch good mirror angles. You learn the Rule right away: Keep meaningful eye contact going with the model's feet, or else. Like *you* could do that?

"Dude, your eyes are gonna get you tossed," whispers Richard at the paint table. "We gotta get you a pair of training sunglasses."

Richard is a slave to his work. Poor bastard. He forces himself to focus, hour after hour, on painting supermodels' butts and breasts. At one point he is doing a

You could not imagine in 1,000 lifetimes that working around naked supermodels could get tedious, but it does—for the rest of the crew. It does not for me. In fact, it is the peak of my career.

particularly tricky section of buck-naked Marisa Miller, who is just slightly more gorgeous than a winning Powerball ticket, when she pulls his chin up and says, "Uh, maybe this is a little late to ask, but you're gay, right?"

Richard's eyebrows slide up his face and he squeals, "Oh, *please*, girl! My boyfriend is going to be *pissed!*"

Later I'll say, "You're not gay, right?"

He shrugs and whispers, "Nah, I'm straight. But from here on in it's gay all day, O.K.?"

Please, girl!

DAY 2: My eyes attempt to stick to the general vicinity of their sockets as Jessica White, who is just slightly sexier than twins in syrup, gets the best-fitting suit of her life. Body painting is exhausting work, not just for the boss and the assistants but for the model, too, since she must stand eight hours while being shaved, airbrushed, painted, touched-up, rubbed down, sponged, grease-penciled, decaled, Sharpied and blow-dried. One model likened it to getting a pap smear and a tattoo at the same time.

DAY 3: You could not imagine in 1,000 lifetimes that working around naked supermodels could get tedious, but it does—for the rest of the crew. It does not for Broom Boy. In fact, the peak of my career arrives as we create a swimsuit on 25-year-old Melissa Keller, who is so beautiful she could make a corpse sit up and tip his hat.

"Strip her and put on nude," Joanne tells me.

Yes! Cool! *What?* Strip her? She's already stripped! Put on nude? How much more nude could she be? She's as nude as a newborn calf! She's nuder than Eve in a sauna! What do they want me to do, remove her skin? But do I make these protests aloud? No, I drag Richard by the elbow to a corner of the room, where he whispers that I'm supposed to remove Melissa's old toe and fingernail polish and put on the color nude, while they continue to fill her nooks and fanny.

Why do I get all the lousy jobs?

It is a little kinky to hold a nude woman's hand as she reads *Vogue*. It is downright J. Edgar Hooverish to blow on a nude woman's little piggy as she talks on her cell to her boyfriend. Perhaps the nude woman wonders why a five-minute job is taking 45 and includes painting parts of her knuckles, but she doesn't say a word. This might be because she hardly knows I exist.

When I'm finally done, she does something that shall bond the two of us forevermore. She looks at me and says, "Hold your hand out." I do. Because she can't move while being painted, she spits her gum into my palm. It's on eBay as we speak.

When she is finally perfect, we fling open the door of the villa and present her to the waiting photo crew, as though she is a debutante at a nude coming-out party. Ladies and gentlemen, wearing a suit by Benjamin Moore, young Melissa Keller!

My 16-year-old son, Jake, is out there. His jaw drops to his sternum.

I hand him my training sunglasses.

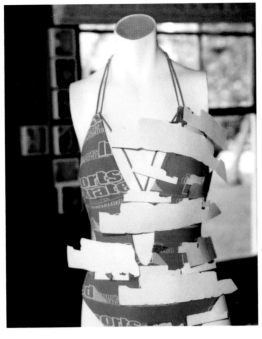
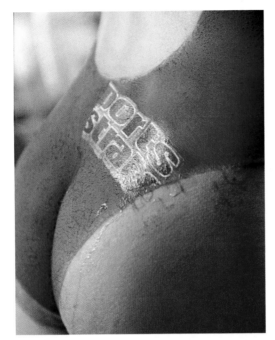
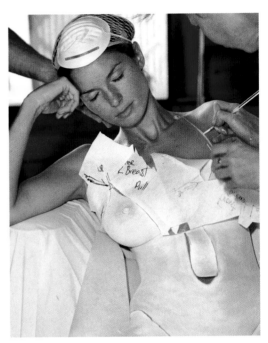
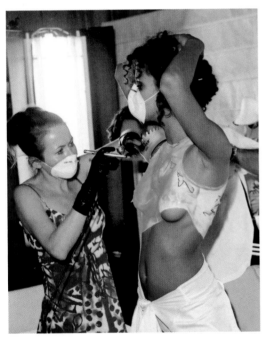
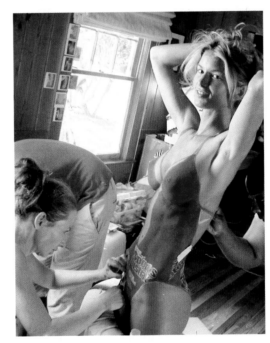
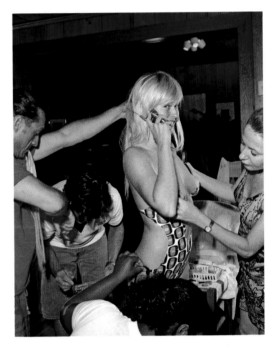
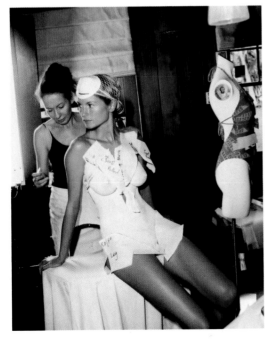
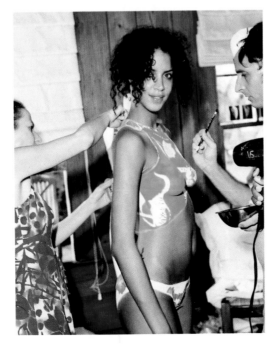
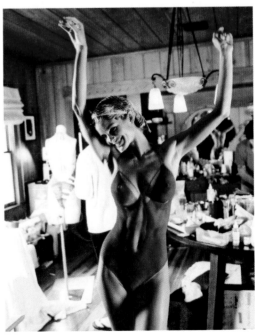

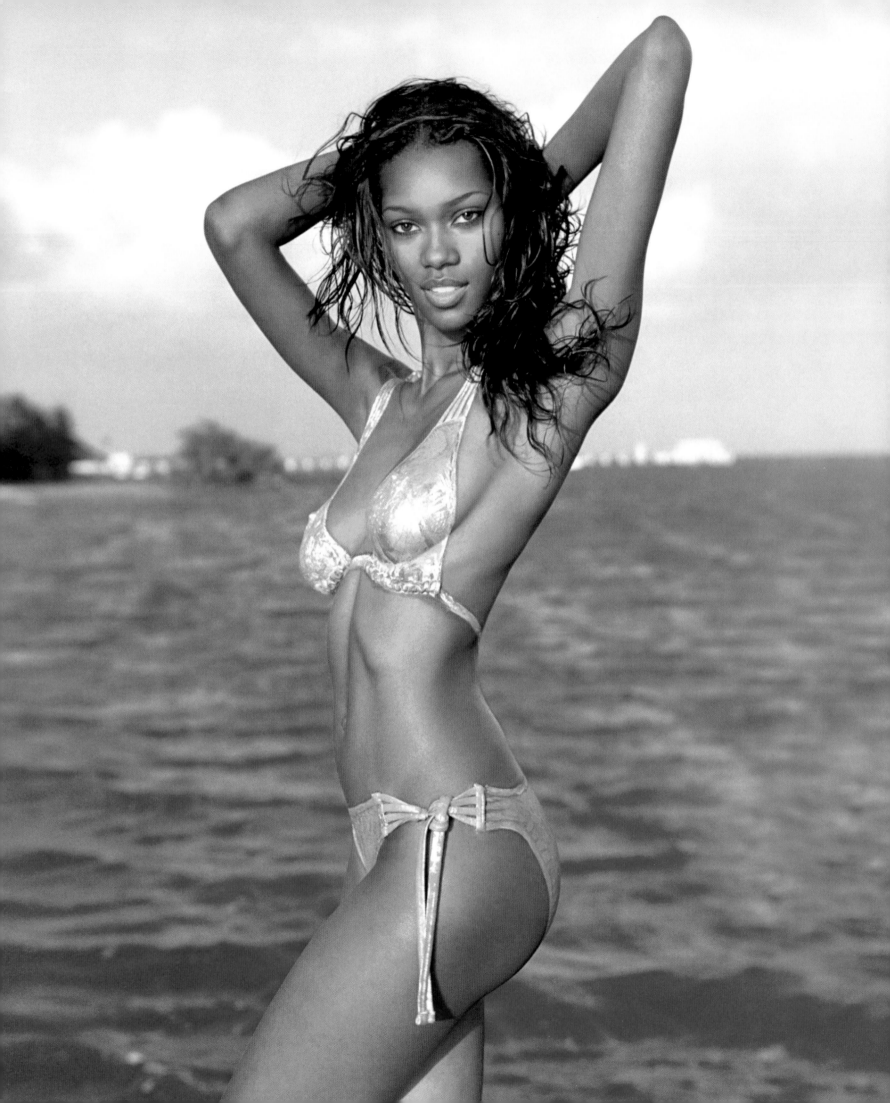

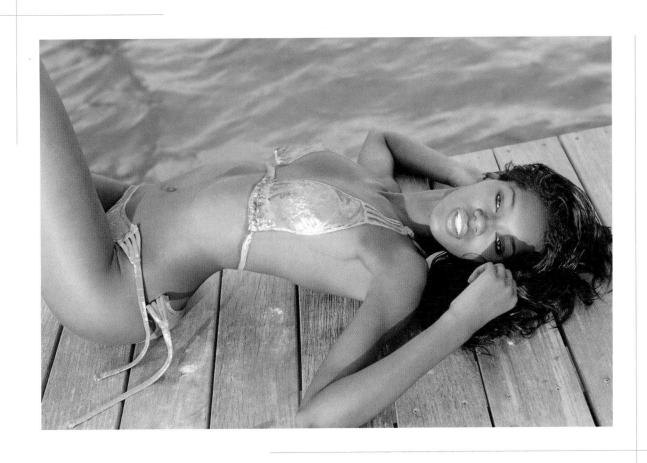

"With Noemie's suit all pulled up like that, the flower no longer reads like a flower—it's a puckered-up flower. I had to work out all that movement and body language to bring it to life."

~ *Joanne Gair*

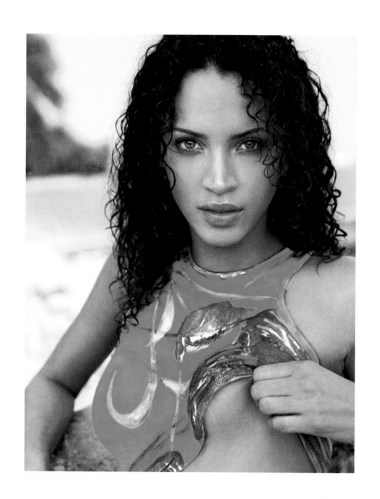

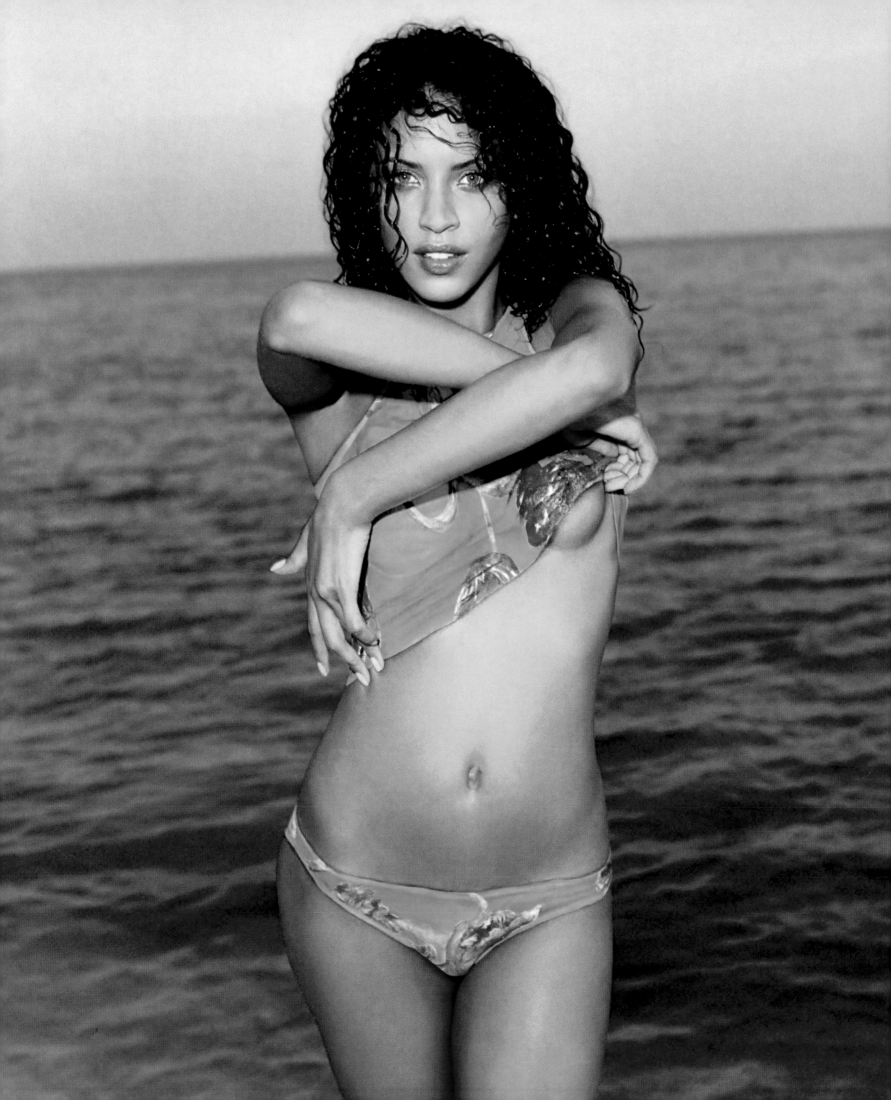

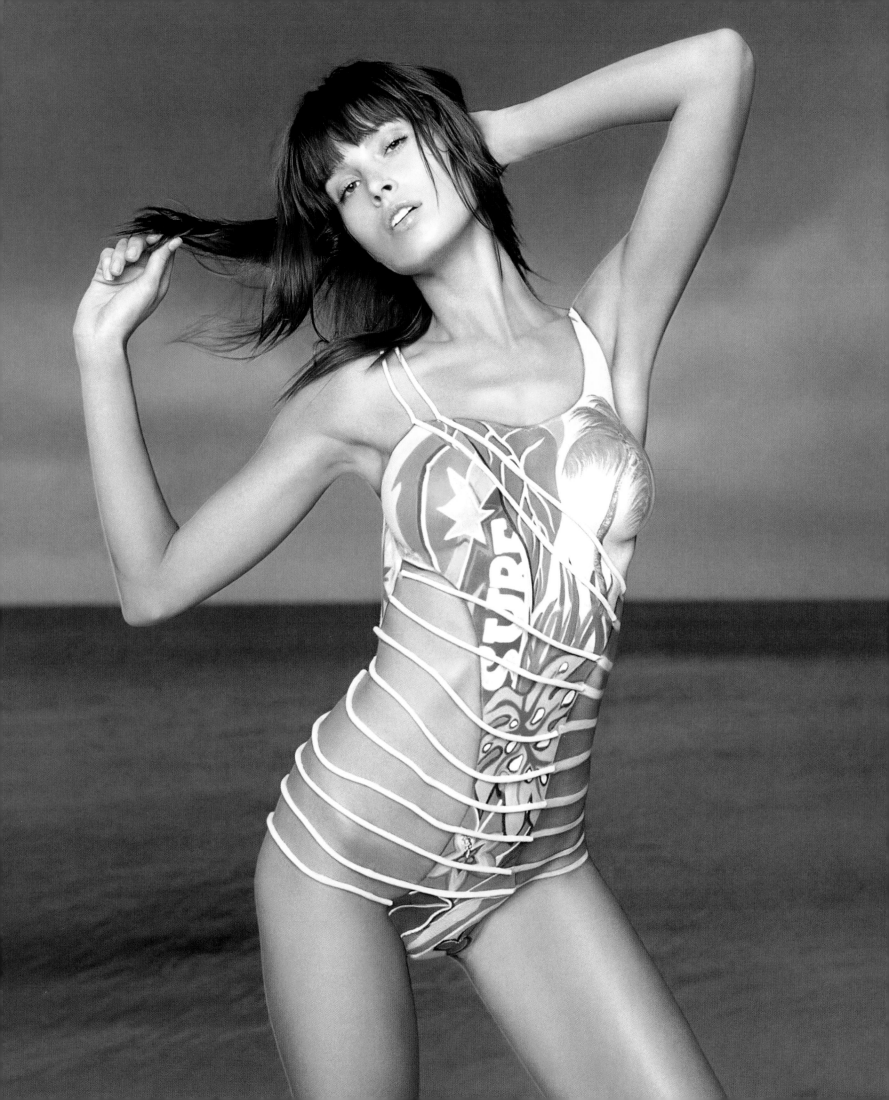

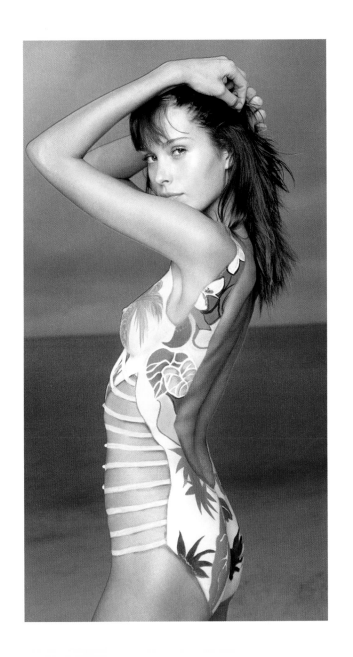

"We're all in awe of Joanne. She's a force of nature, a master artist. She watches every tiny movement and knows exactly what works, so every page is a surprise— something the reader has never seen before."

~ *Diane Smith, SI swimsuit editor*

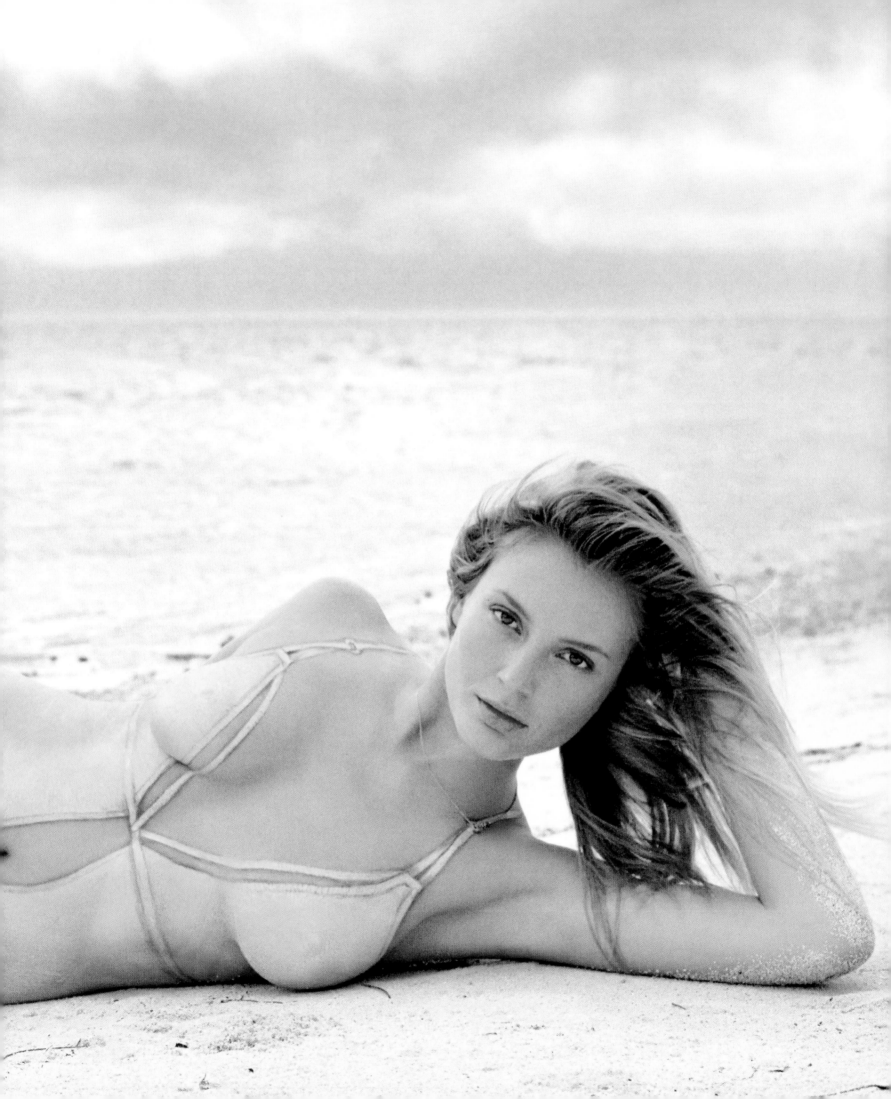

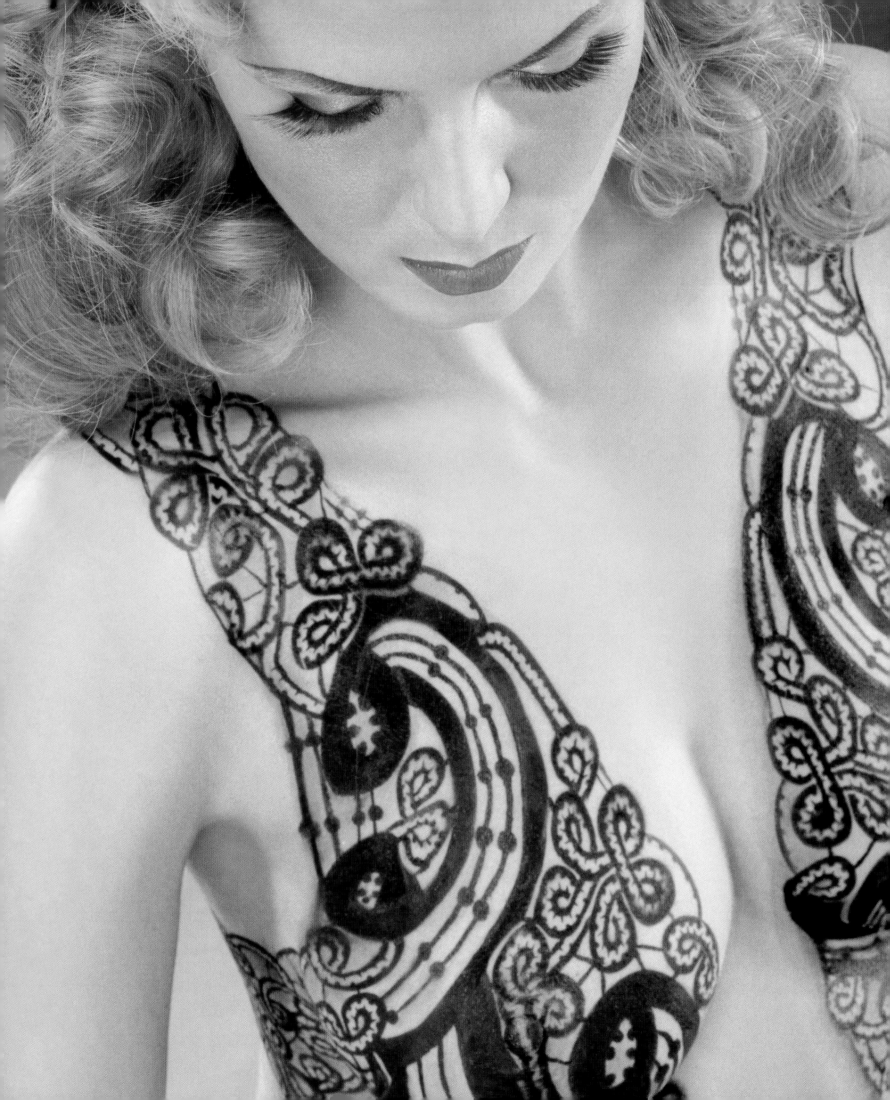

I

Pinup DREAM

Photographs by
JOANNE GAIR

In homage to the glamour girls of old Hollywood, the world's preeminent body painter applies her brush to Heidi Klum, one of the world's heavenly bodies

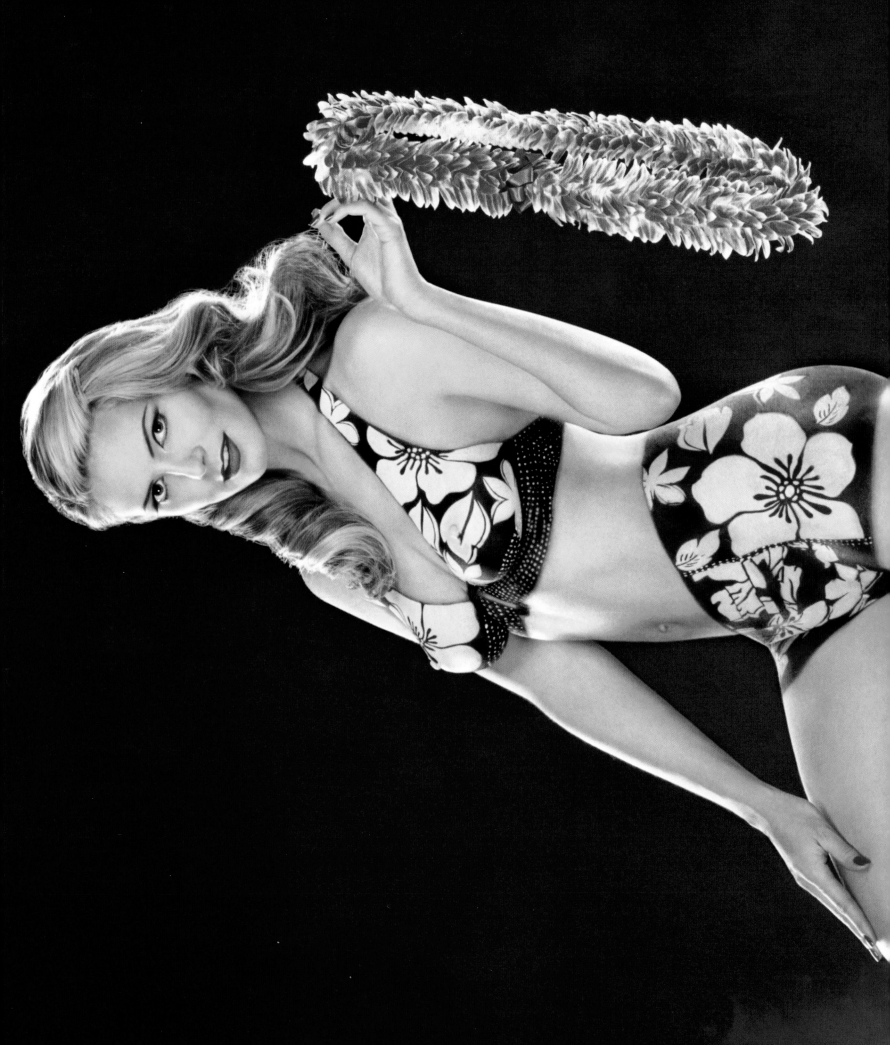

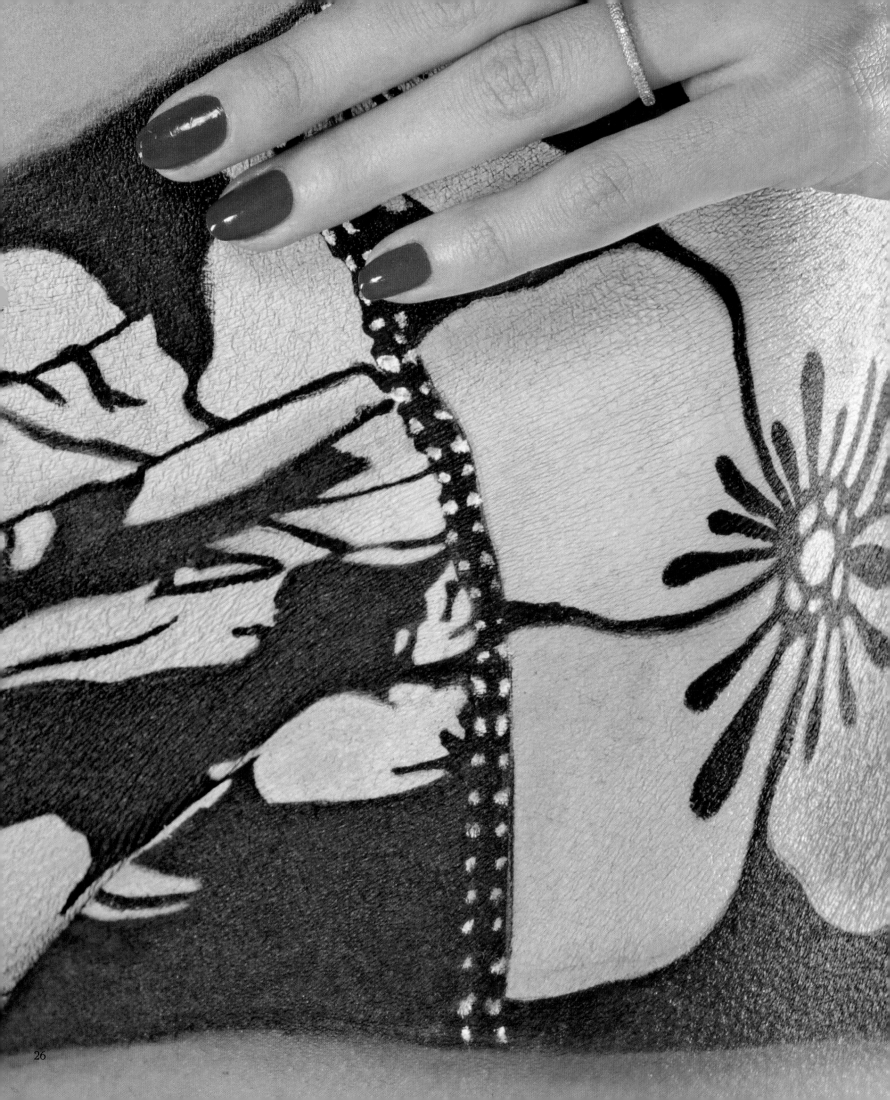

"These pinups are something special, more exciting to me than a regular photo shoot. It's really cool to transform into these different people. It's boring to just be me all the time"

~ *Heidi Klum*

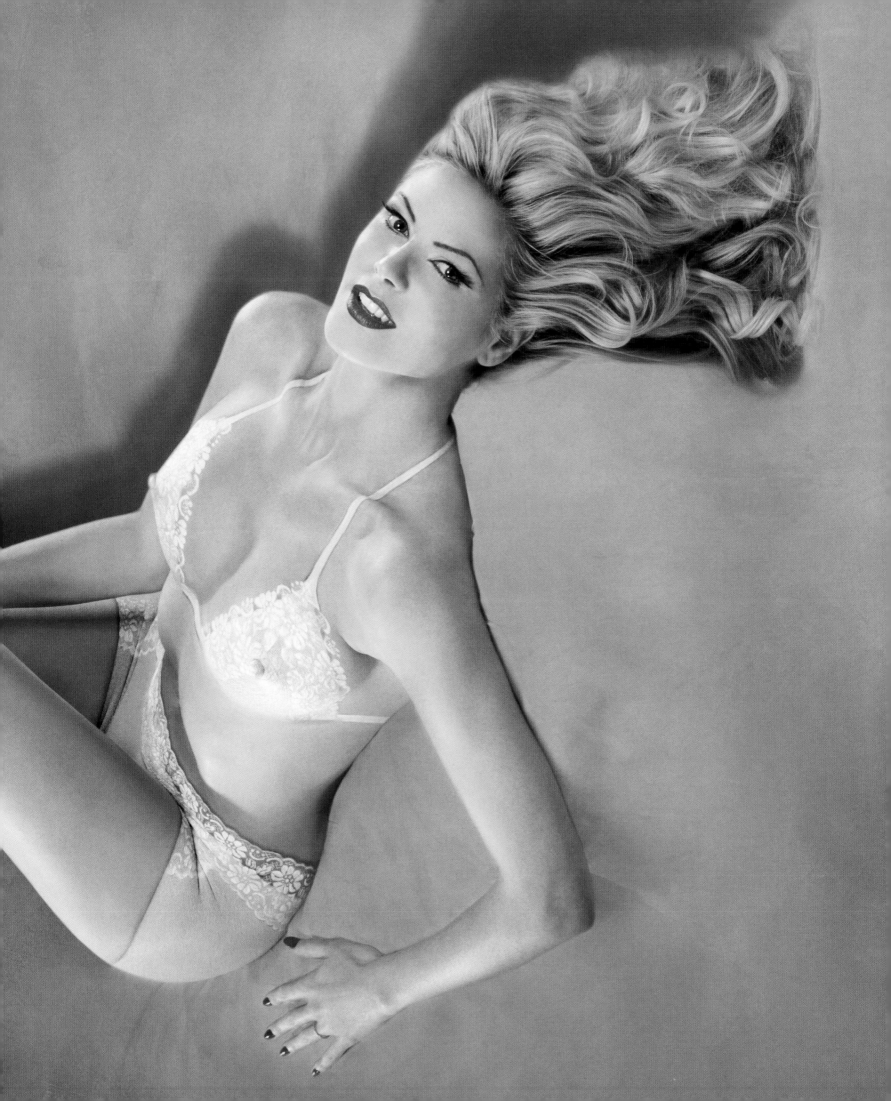

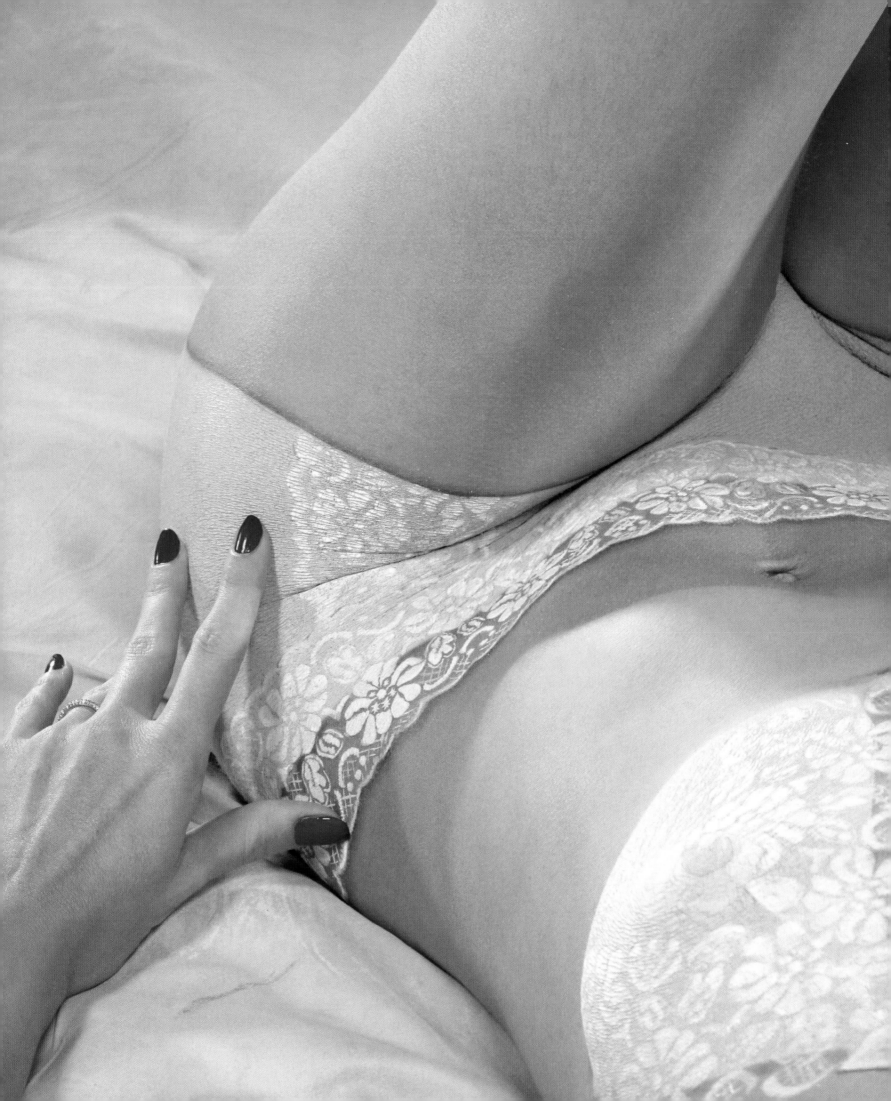

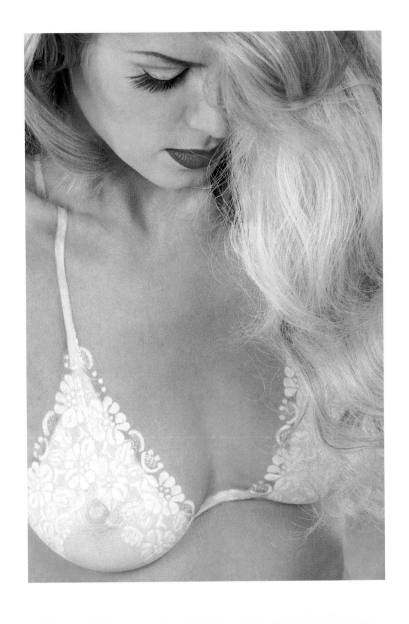

"Now I'm hosting the *Next Top Model* show in Germany. As a highlight I have Joanne paint the last four girls who are left in the competition, and they love it."

~ *Heidi Klum*

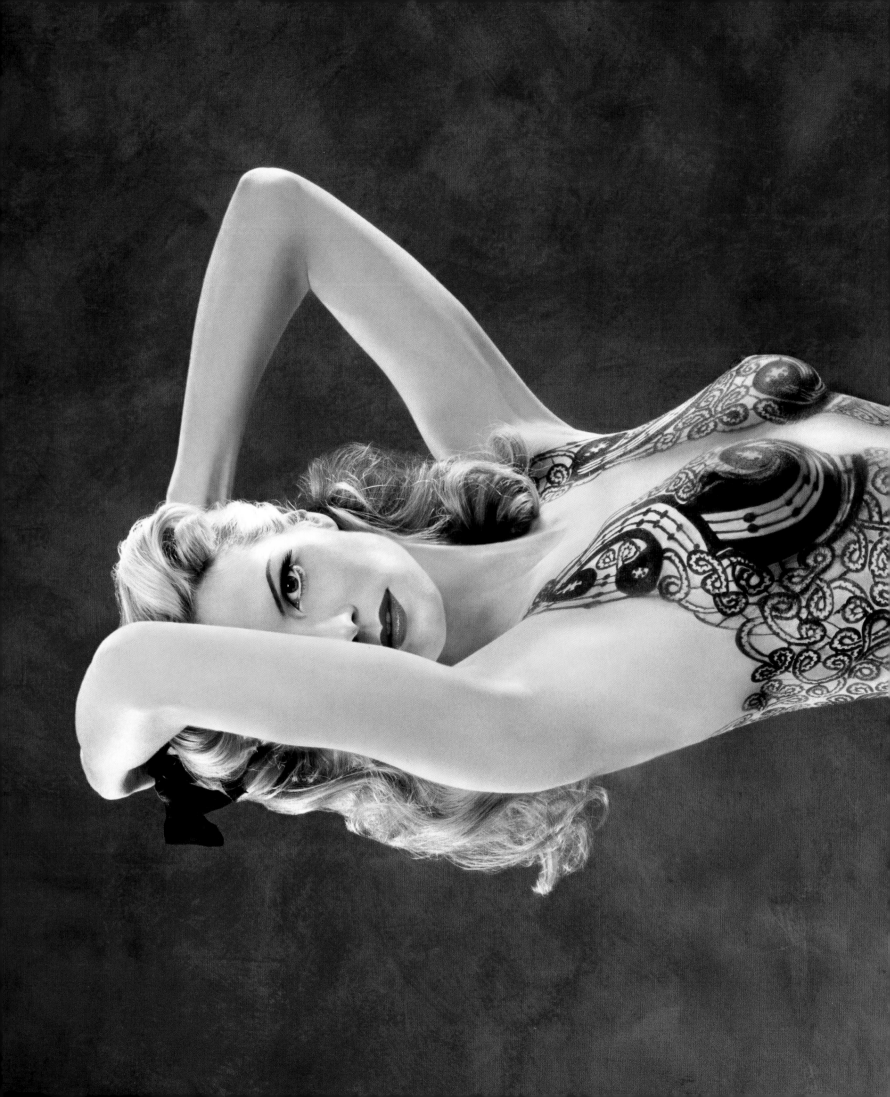

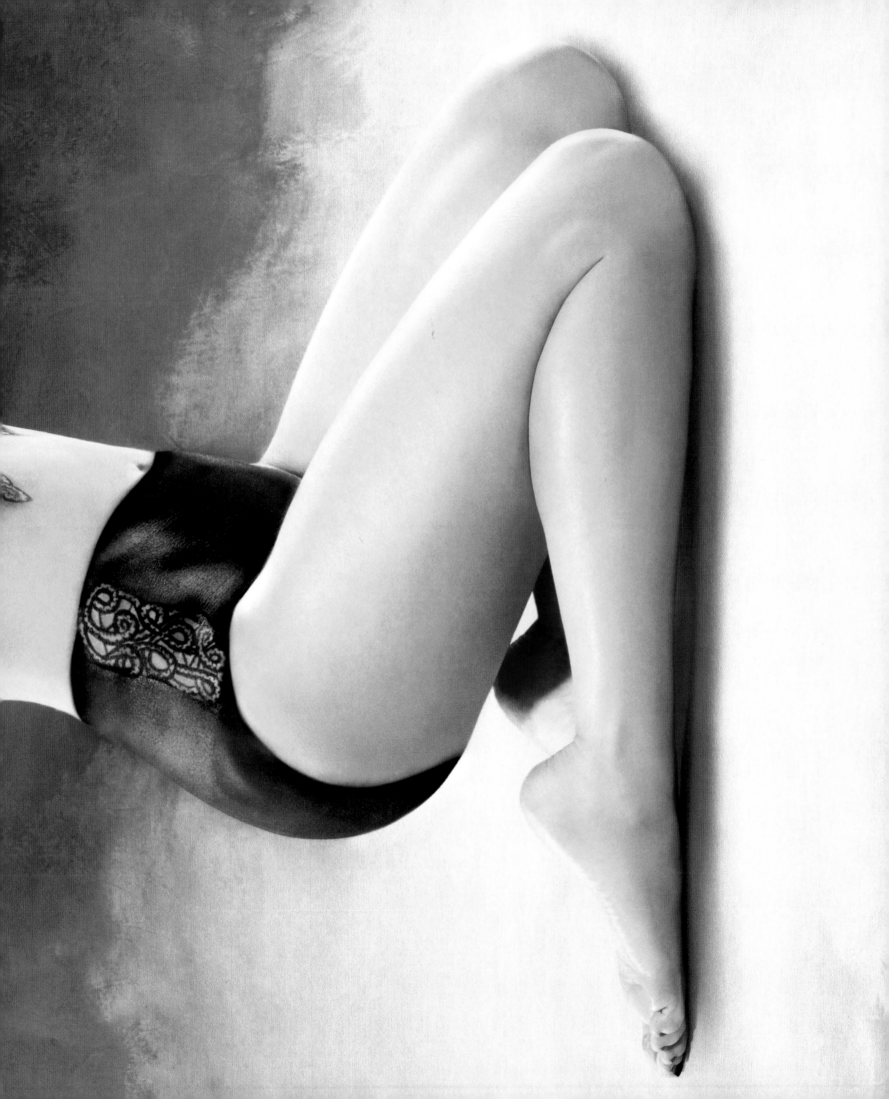

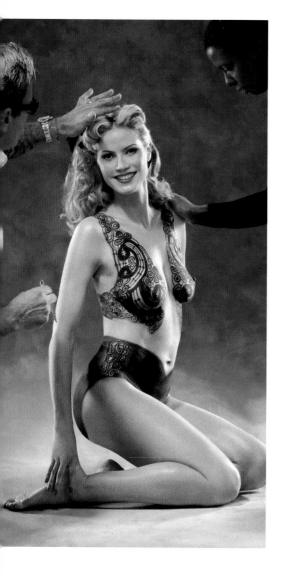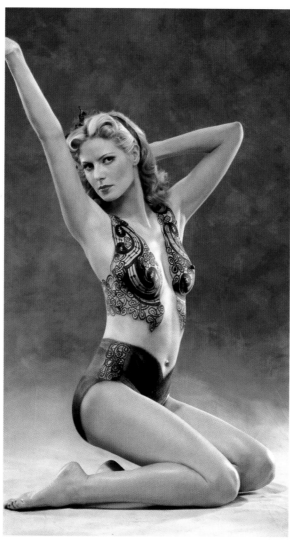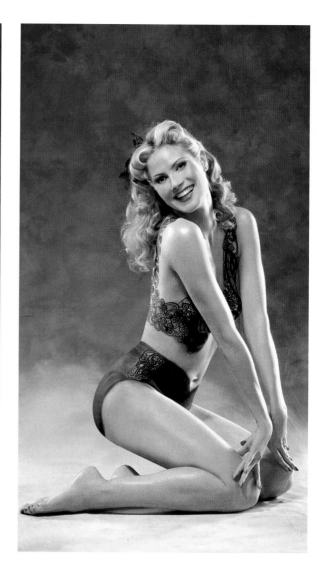

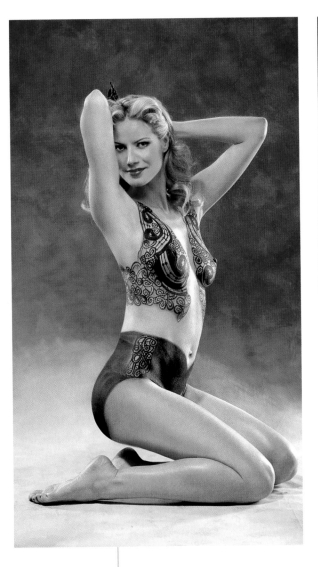
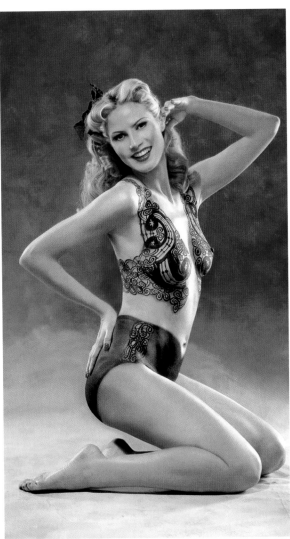
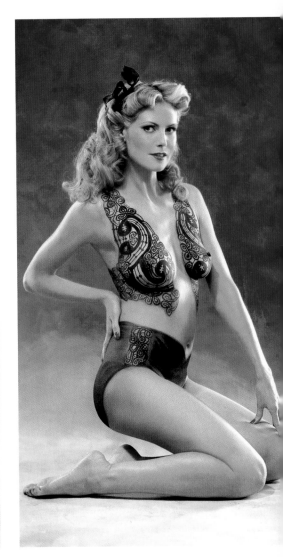

"To go into a different role and camp it up—that's fun for me."

~ Heidi Klum

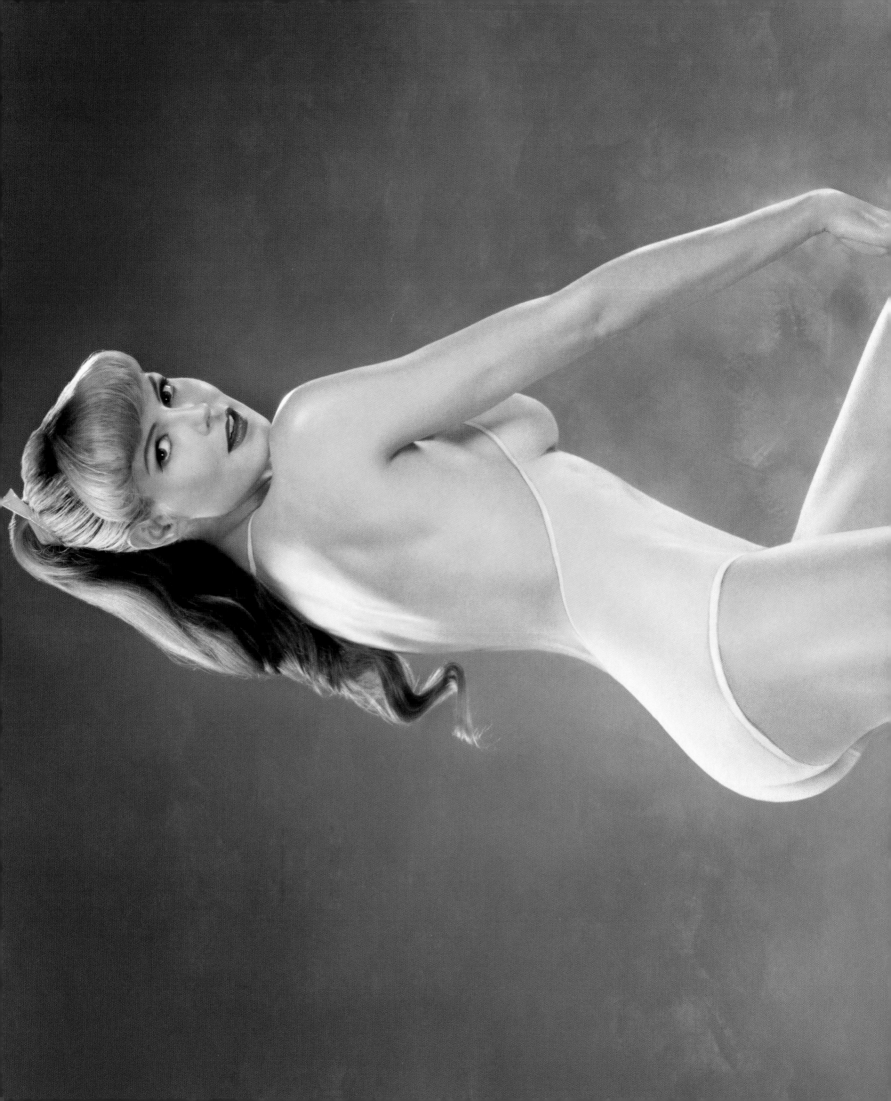

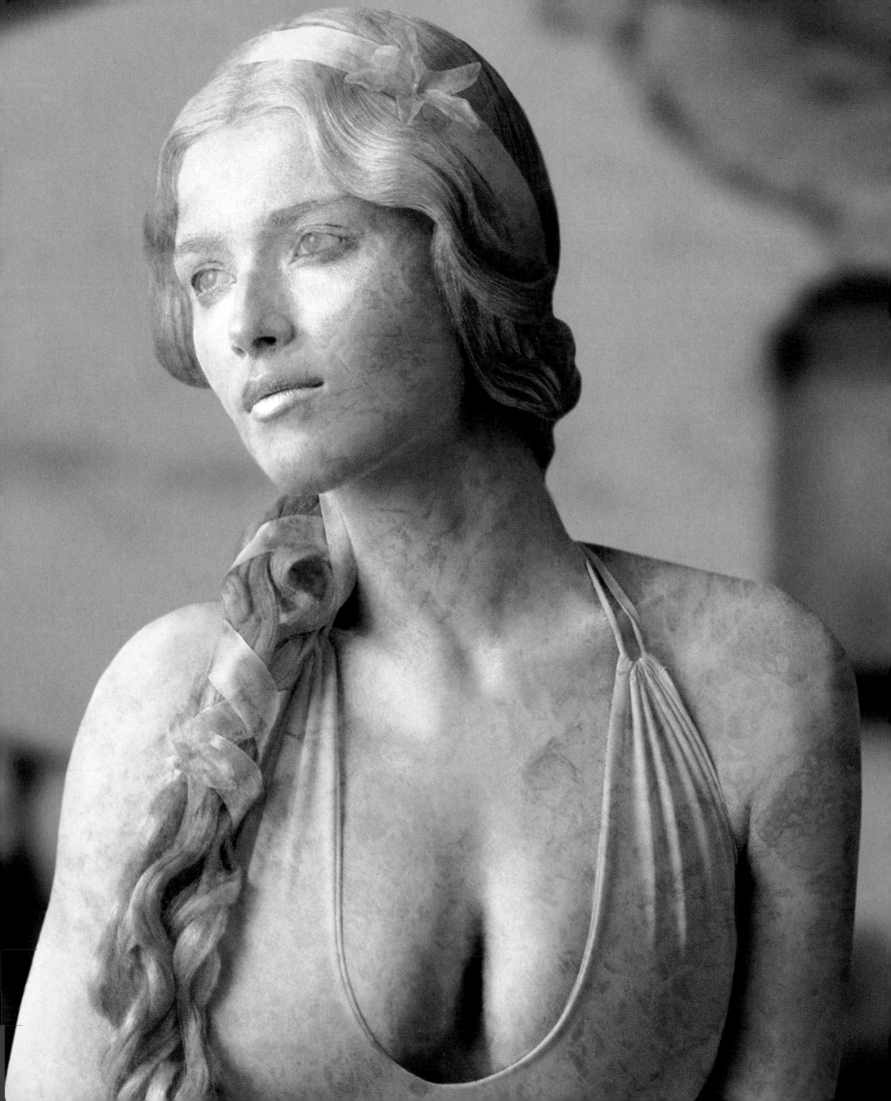

T

Statue-ESQUE

Photographs by
JAMES PORTO

These goddesses are used to being bronzed, but that usually refers to their tans

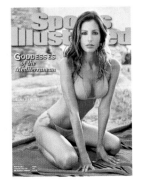

"When we shot these statue photos, Molly Sims was a hoot. She said, 'I like being froggy green.' "

~ *Joanne Gair*

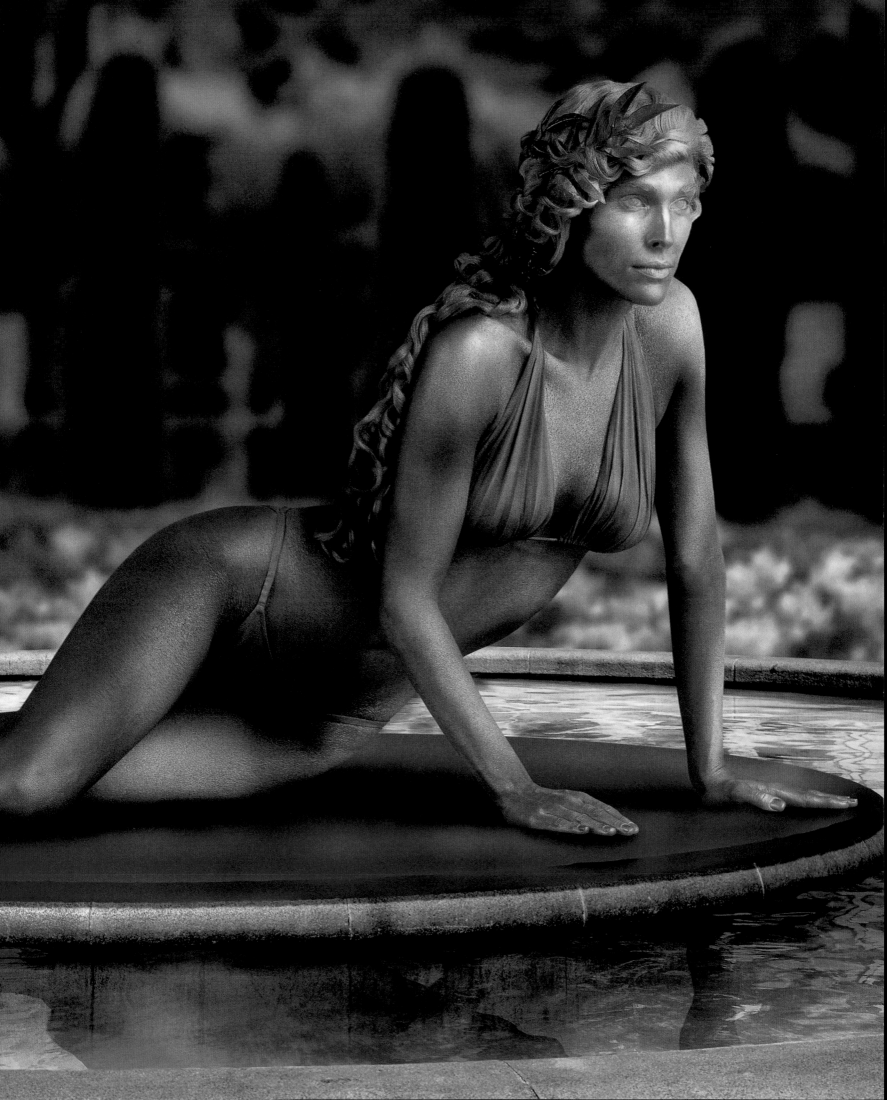

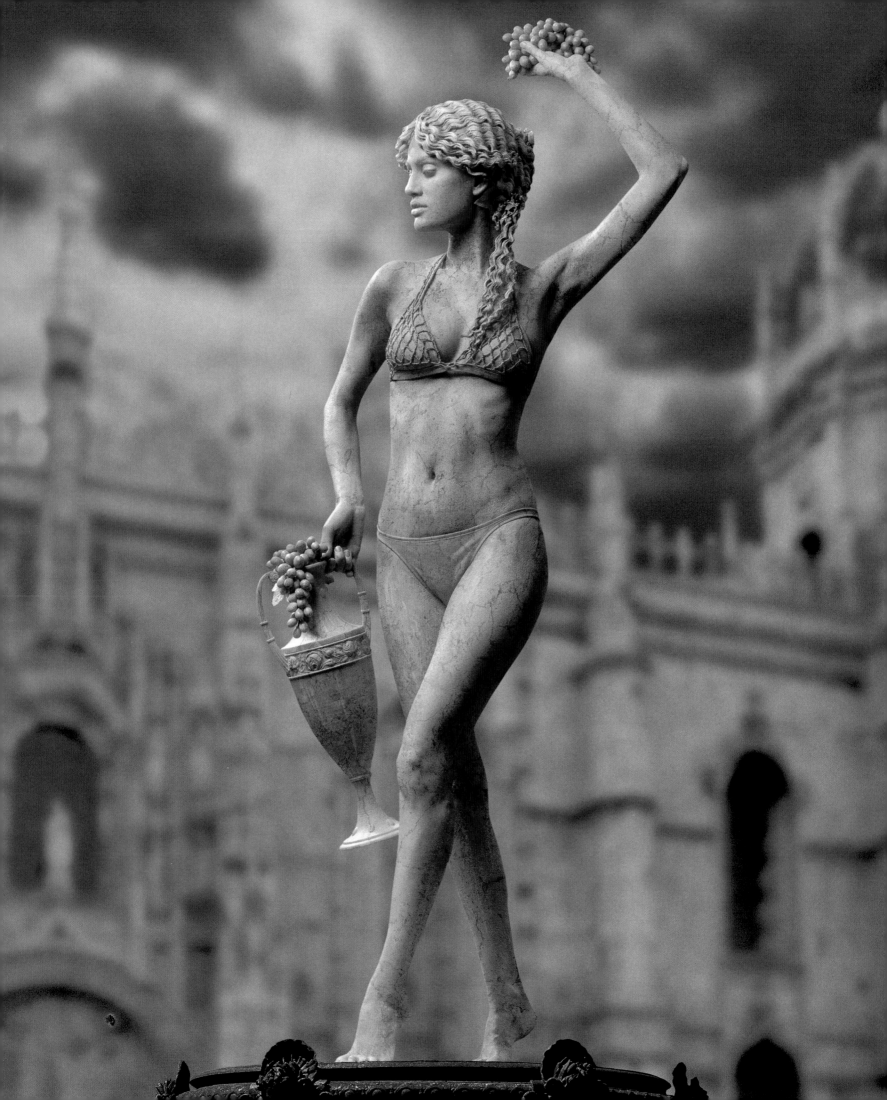

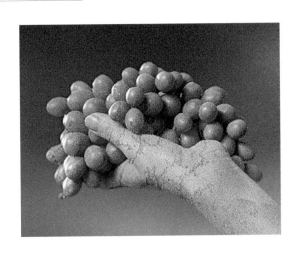

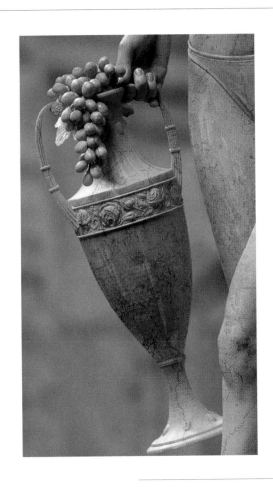

"On the statue shots, the challenge for me was that underneath the paint, everything— the wigs, the suits, the skin—was a different color. I literally had to spray the entire body."

~ Joanne Gair

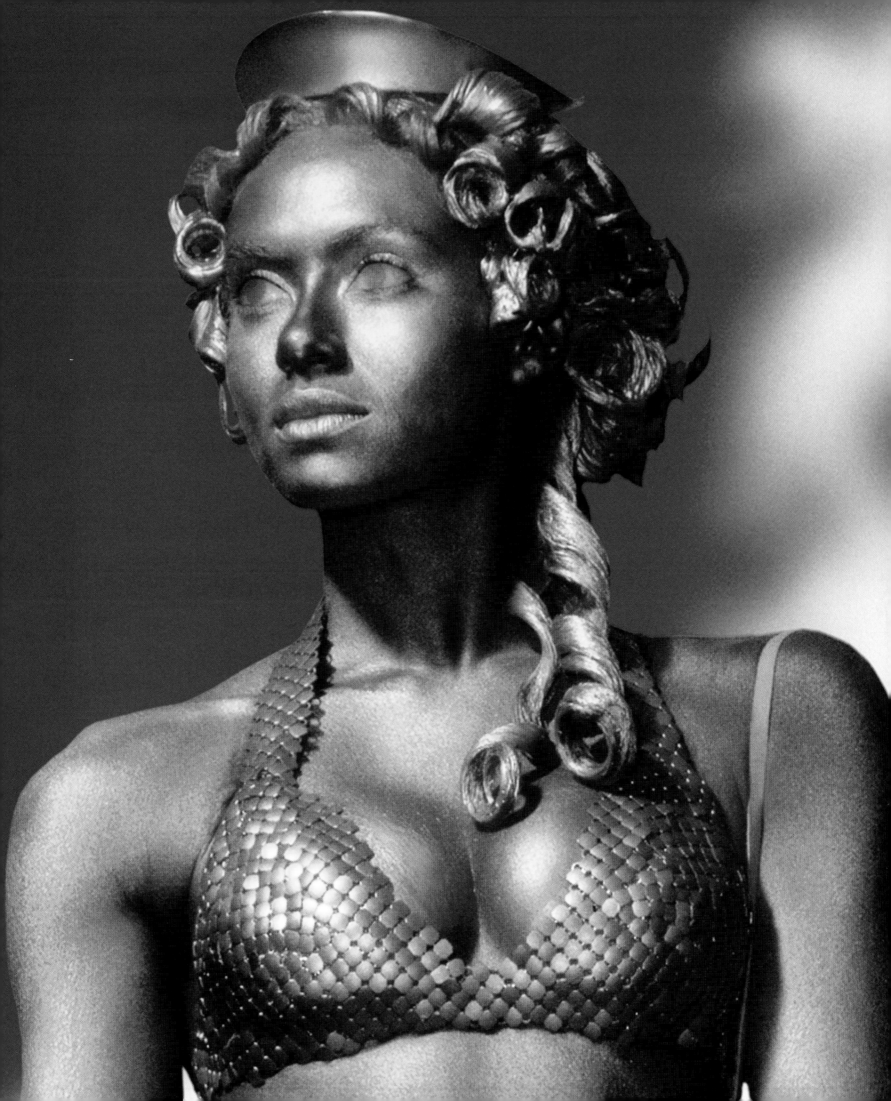

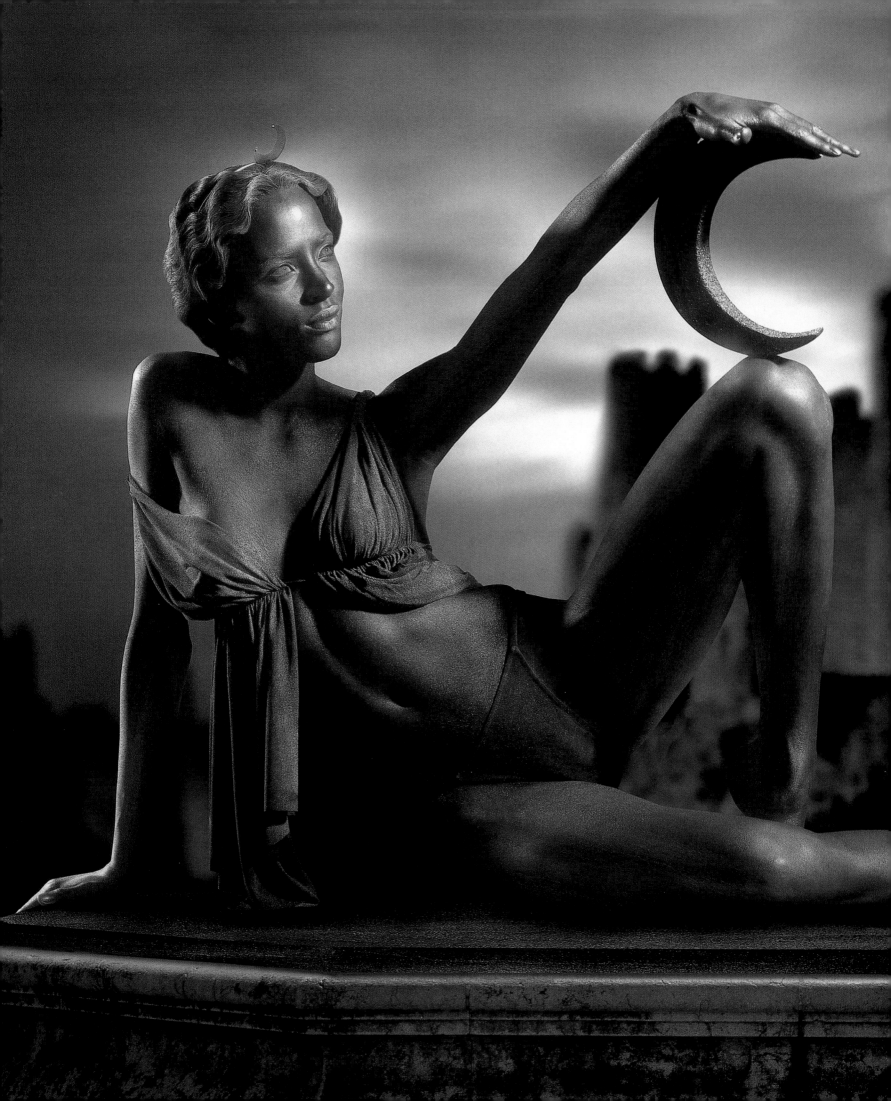

"Each one
of these needs
an undercoat,
so there was a lot
of spraying.
This is when we
realized, Oh my
God, we've got
fuzzy statues.
We really
have to shave
everything."

~ Joanne Gair

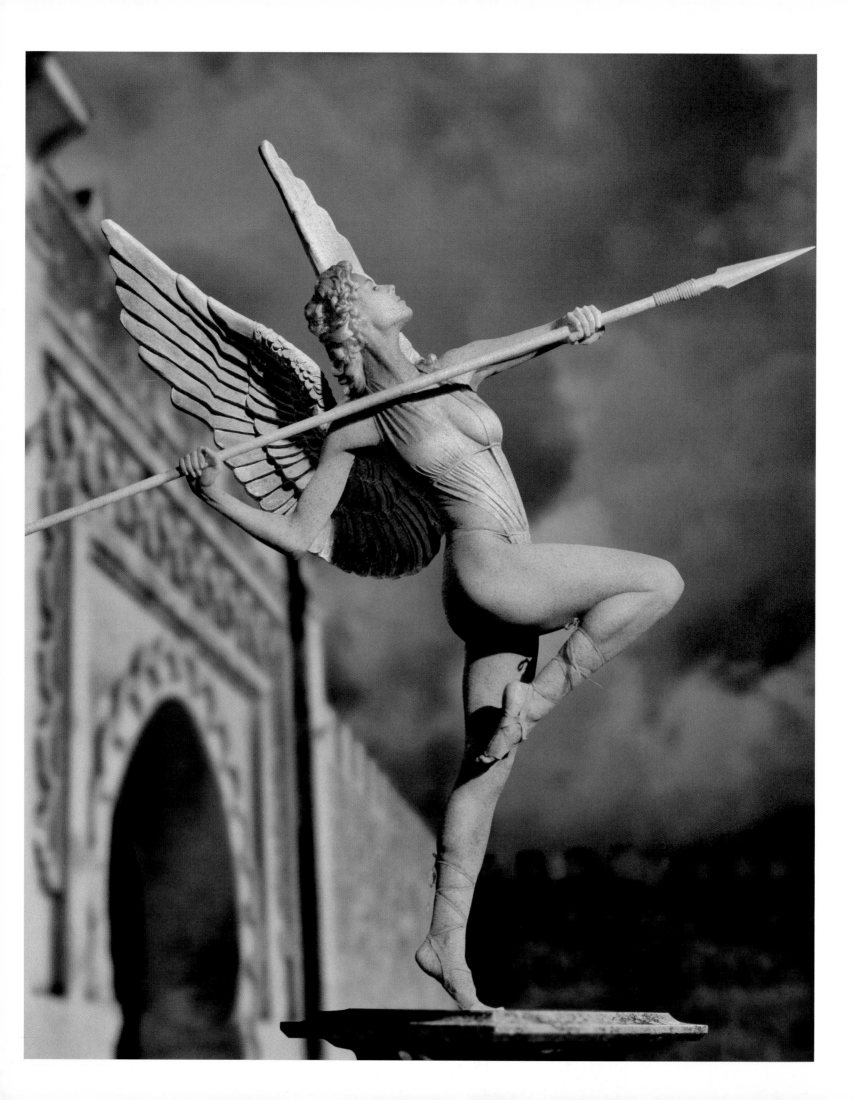

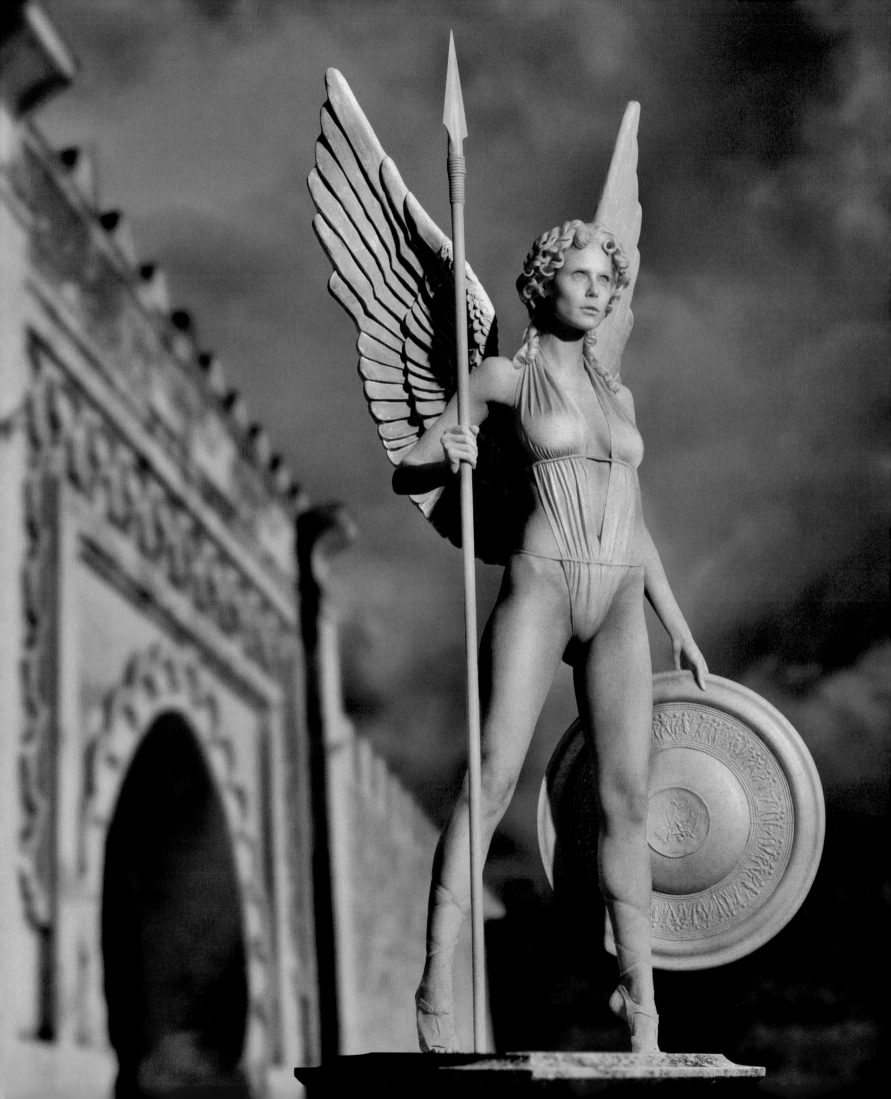

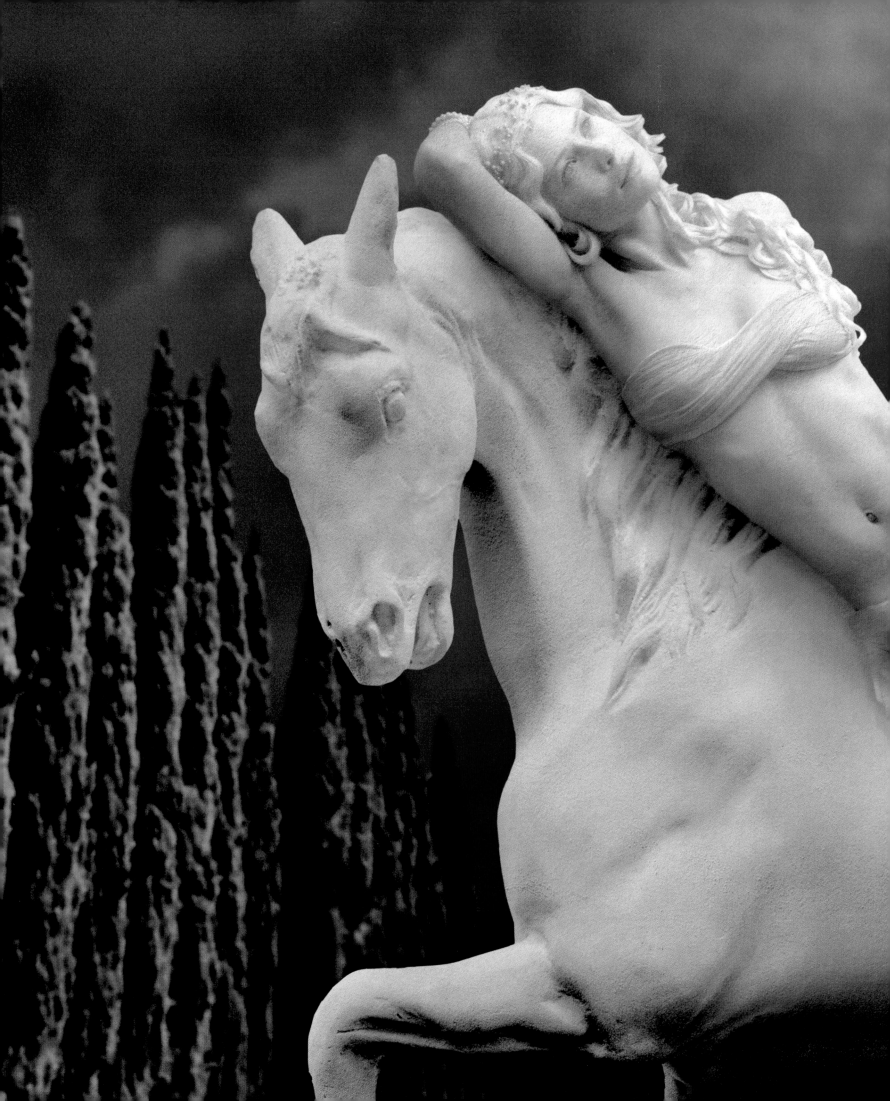

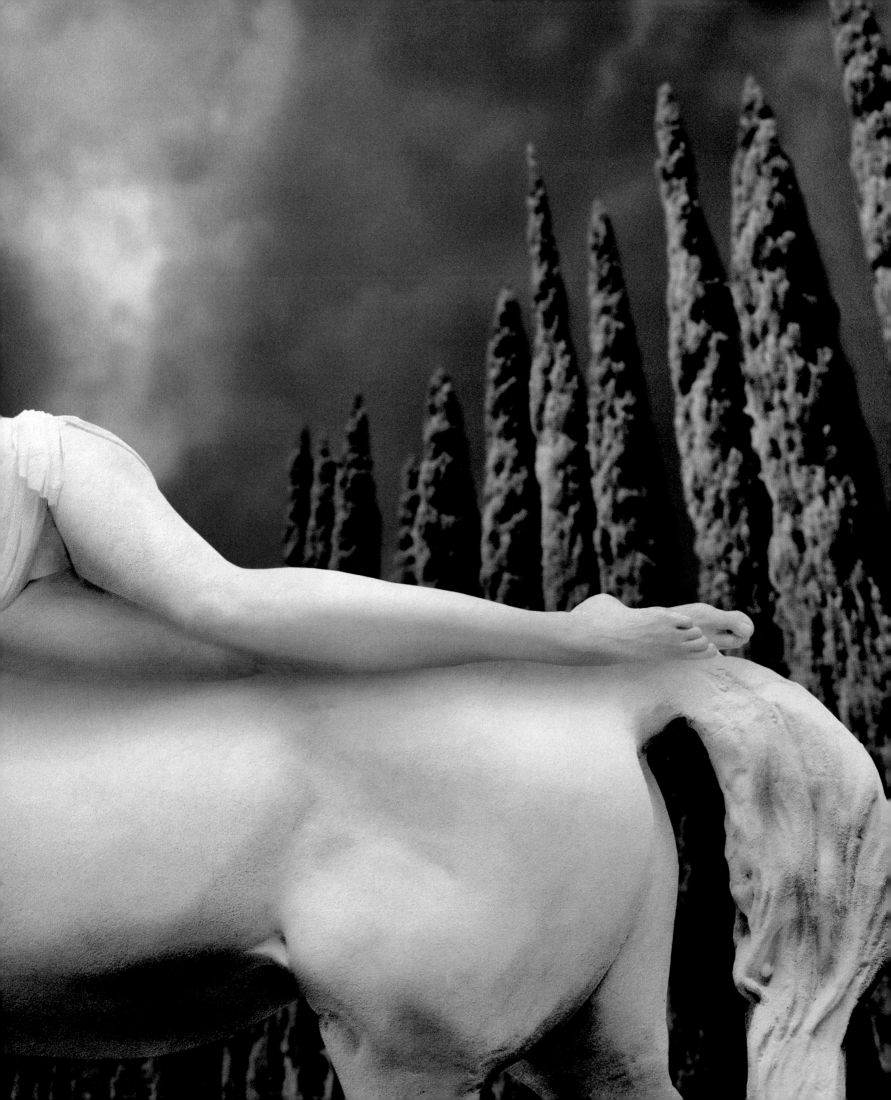

COVER: SARAH O'HARE

2 THE TOOLS OF JOANNE GAIR'S TRADE

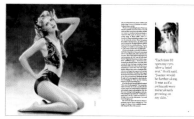

4 HEIDI KLUM

6 FERNANDA TAVARES (AS AURORA)

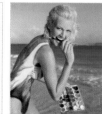

8 SARAH

10 JOANNE AT WORK; 11 MARISA MILLER

12 HEIDI; 13 JOANNE AND HEIDI

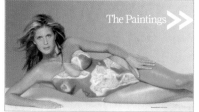

14 RACHEL HUNTER

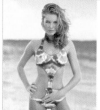

16 REBECCA ROMIJN

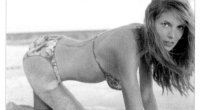

18 HEIDI

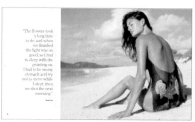

20 YAMILA DIAZ

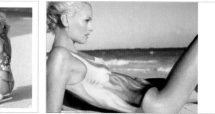

22 SARAH

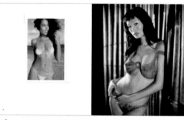

24 SARAH

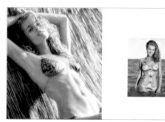

26 TAMARA SPOELDER; 27 AUDREY QUOCK

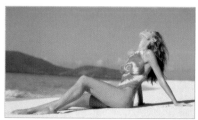

28 REBECCA; 29 REBECCA

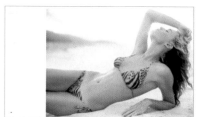

30 REBECCA

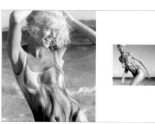

32 SARAH

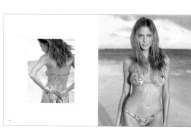

34 HEIDI

36 HEIDI

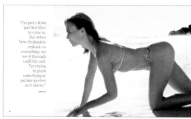

38 MICHELLE BEHENNAH

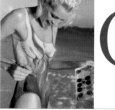

40 SARAH

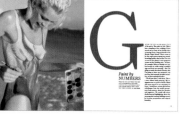

42 HEIDI; 43 JOANNE PAINTING HEIDI

44 JOANNE AND CREW WITH MICHELLE; 45. . . AND SARAH

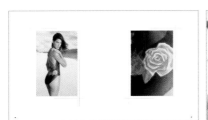
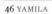

46 YAMILA

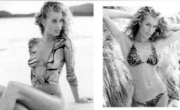
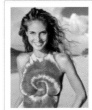
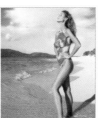

48 REBECCA

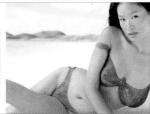

50 HEIDI

52 AUDREY

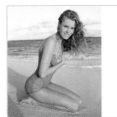
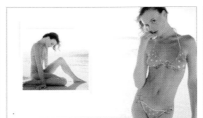
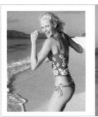
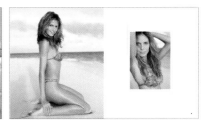

54 REBECCA

56 MICHELLE

58 SARAH

60 HEIDI

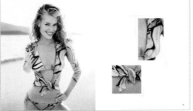
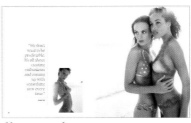
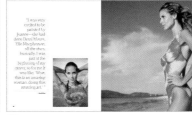

62 YAMILA

64 REBECCA

66 MICHELLE; **67** MICHELLE AND TAMARA

68 HEIDI

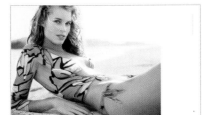
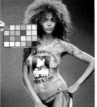
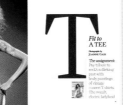
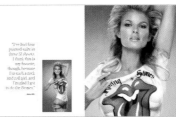
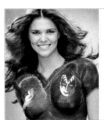

70 REBECCA

72 ANA PAULA ARAUJO

74 MARISA

76 DANIELLA SARAHYBA

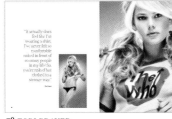
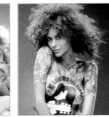
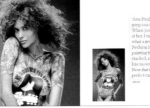

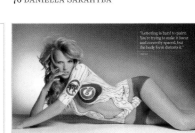

78 TORI PRAVER

80 ANA PAULA

82 BRIDGET HALL

84 ANNE V

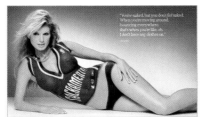
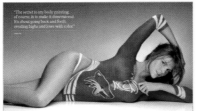
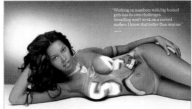

86 MARISA

88 DANIELLA

90 JESSICA WHITE

92 JOANNE, DIANE SMITH AND CREW BEHIND THE SCENES

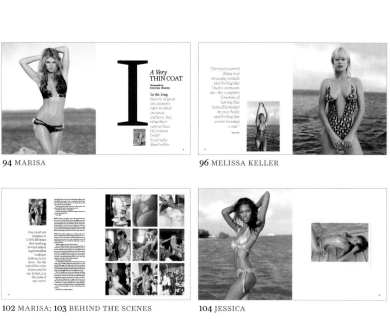
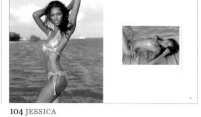
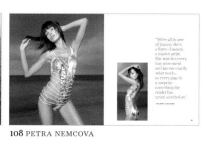
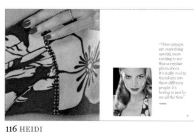
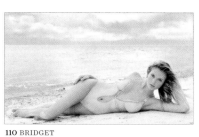
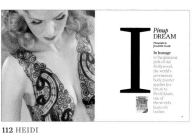
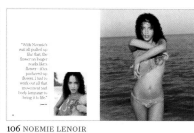
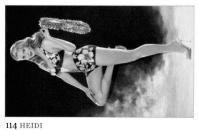
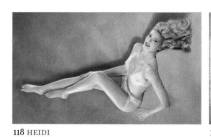
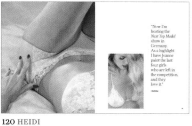
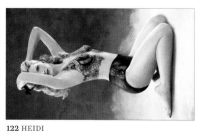
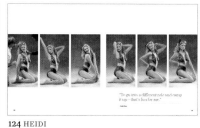
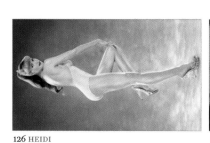
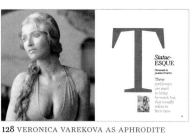
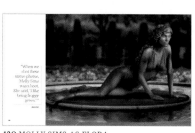
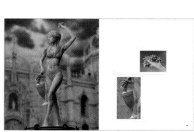
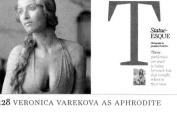
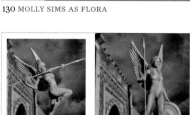
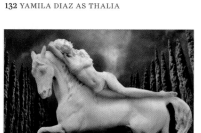

The paintings and photographs in this book would not have been possible without the work of a multitude of talented individuals and the products at their disposal. First and foremost is Spencer Franklin, who is vital, on every level, to the work of Joanne Gair. Reel Creations must top the list of the companies providing makeup and supplies, but thanks are also in order for AmazingCosmetics, Dinair Airbrush Makeup Systems, M·A·C Cosmetics, Trendy Tribals and Tinsley Transfers. Thanks, too, to the many people who paid scrupulous attention to every detail, among them makeup artists Reyna Pecot, Isaac Prado, Mark Garbarino, Tipare Iti, Carly Jane Chappell, Helen Eleftheriou, Ramon Espinoza and Carol-Anne Ryce-Paul; hairstylists Shay Ashual, Rick Gradone, Richard Keogh, Patrick Melville, Oribe and Roque, and Ric Pipino; manicurists Michina Koide and Mary Chicka; crew members Nikko Kefalas, Michael Bergan, Stewart Price, James Moritz and Belinda Merrie; and the retouch artists at Digital Retouch.

It should go without saying—but won't—that the entire editorial and production crew is grateful to SI Editor Terry McDonell for his unflagging support.

Time Inc. Home Entertainment Publisher, Richard Fraiman; General Manager, Steven Sandonato; Executive Director, Marketing Services, Carol Pittard; Director, Retail & Sales, Tom Mifsud; Director, New Product Development, Peter Harper; Assistant Director, Brand Marketing, Laura Adam; Vice President and Deputy General Counsel, Robin Bierstedt; Book Production Manager, Jonathan Polsky; Design & Prepress Manager, Anne-Michelle Gallero; Brand Manager, Danielle Terwilliger; SI Director, New Product Development, Bruce Kaufman.

Back cover photographs by (clockwise from top left): Michael Zeppetello, Antoine Verglas, Joanne Gair, Antoine Verglas, Steven White, Joanne Gair.